DRAWINGS
MICHELANGELO

Michel Cagniolo

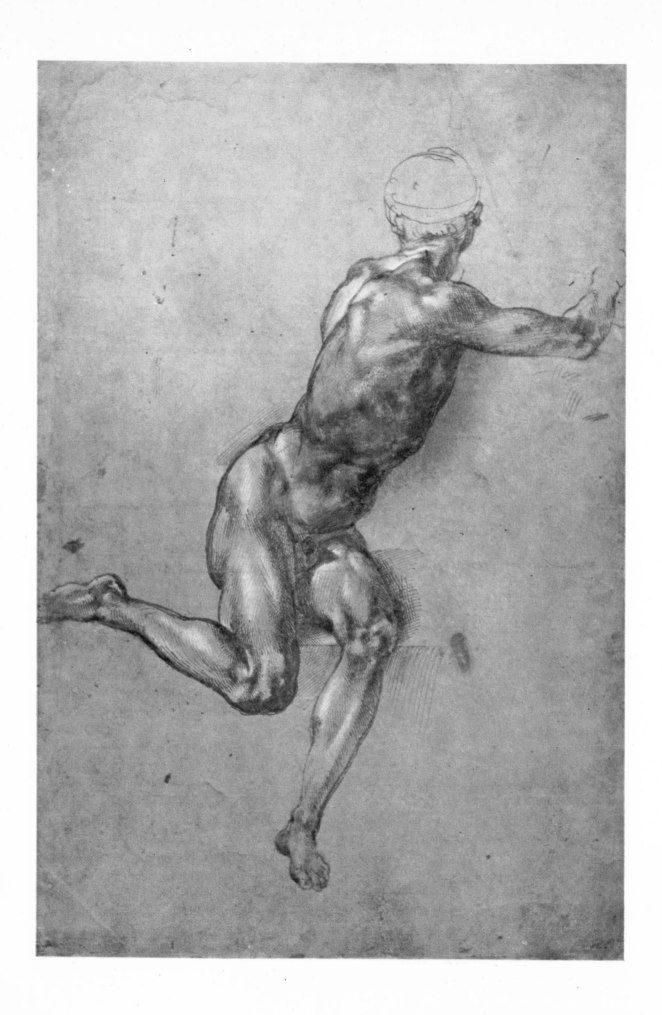

DRAWINGS
MICHELANGELO

by
Pavel Preiss

Control Data Arts
Minneapolis, Minnesota
1982

MICHELANGELO: Drawings
by Pavel Preiss

Designer: Aleš Krejča
Editor, English language edition: Susan Perry
Supervising editor, English language edition: Pamela Espeland
Translated from the French by Francis Harrison
Designers, cover and text for English language edition: Ned Skubic and Carol Evans

Library of Congress Cataloging in Publication Data

Michelangelo Buonarroti, 1475–1564.
 Michelangelo : drawings.

 Translated from the French.
 Bibliography: p. 177
 1. Michelangelo Buonarroti, 1475–1564. I. Preiss,
Pavel. II. Title
NC257.B8A4 1981 741.945 81–3169
ISBN 0–89893–174–6 AACR2

CONTENTS

Notes on the Collotype Process

In order to achieve the most accurate reproductions of Michelangelo's drawings possible, the publishers of this volume have elected to use a special photographic process called *collotype*. This expensive and old-fashioned printing method was invented in 1855 and put into commercial use in 1868. At most it can produce only a few thousand copies, yet because of its ability to render fine detail it remains in demand for short runs of fine art prints or illustrations and for limited editions of books.

A collotype is made on a sheet of ground glass coated with bichromated gelatin. The plate is first dried in an oven until the gelatin reticulates into a pattern of almost microscopic cracks. A continuous-tone negative is then held up to the plate and light is passed through both the plate and the negative, causing the gelatin to harden in direct proportion to the tones of the negative.

Following this step the plate is washed to remove the bichromate and treated with a glycerine solution that moistens the areas which remained less hard after their exposure to light. A greasy lithographic ink is then rolled over the plate. The ink is repelled by the moist areas but accepted by the tiny reticulation cracks of the dry, hardened areas. Finally, paper is pressed against the plate and the image is transferred.

The collotype process is unsuitable for long print runs due to the fact that the delicate gelatin surface begins to slowly deteriorate after approximately one thousand copies are made. Without the gelatin, however, it would not be possible to reproduce with such accuracy the detailing and shading of the original work of art. Thus, while the process does not lend itself to mass production, it does result in superb prints that capture the beauty and intensity of Michelangelo's drawings.

INTRODUCTION

Today this sixth of March . . . there was born to me a male child; I named him Michelangelo . . .

— From the journal of Lodovico Buonarroti, 1475

Sculptor, painter, architect, and poet, Michelangelo Buonarroti was the greatest artist of his time — the Renaissance — and perhaps of all time. He was born on March 6, 1475, in a wild and beautiful area of Italy called the Casetino, forty miles southwest of Florence. His father, Lodovico Buonarroti, was a proud, vain man, a member of a respected but impoverished Florentine family. His mother was a sad, shadowy figure who died young after bearing five sons; Michelangelo never really knew her.

Michelangelo spent most of the first years of his life in the countryside home of his wet nurse and her husband, a stone quarryman. There he learned how to handle a hammer and chisel, absorbing this skill, as he once said, "with my nurse's milk." When Michelangelo was ten his father remarried, abruptly removed his son from his idyllic life among the stonecutters, and took him to Florence to attend school. The boy stubbornly resisted his tutor and learned little besides how to read and write Italian. His interests already lay elsewhere: he was fascinated by the arts. He began sketching and made friends among boys who were apprenticed to painters and sculptors. This passion for the arts infuriated Lodovico, who wanted his son to enter the mercantile trade and thus restore the family fortune. Even though his father's anger sometimes erupted in beatings, Michelangelo persisted, and in 1488 he was apprenticed to the master painter Domenico Ghirlandaio. He was then thirteen years old.

1

Michelangelo's genius was evident almost from the beginning. Ghirlandaio himself was so struck by the power and originality of his young apprentice's work that he once exclaimed, "This boy knows more than I do!" The talented youth also caught the eye of Lorenzo de' Medici, Florence's leading citizen and statesman, who in 1489 invited him into his palatial home to study sculpture under the direction of the master teacher Bertoldo di Giovanni. In this princely setting Michelangelo thrived, becoming a skilled poet as well as a sculptor.

But this idyll, like his earlier one among the stonecutters, soon came to an abrupt end. In 1492, at the age of forty-three, Lorenzo died from a combination of gout and rheumatic fever. Piero, Lorenzo's eldest son, was quick to take over the leadership of the House of Medici and of Florence. Piero had long been jealous of his father's almost paternal affection for Michelangelo, and it came as no surprise when he did not ask the young artist to stay on at the palace. Deprived of both his patron and his teacher, Michelangelo returned to his father's house. By now firmly committed to his art, he immersed himself in the study of anatomy — a topic which so intrigued him that he went so far as to surreptitiously dissect cadavers at a nearby hospital. During this period he was also introduced to the incandescent preachings of Girolamo Savonarola, a Dominican friar who has since been labeled the harbinger of the Reformation. Savonarola's chilling sermons on sin and the urges of the flesh deeply affected the shy, impressionable young Michelangelo; an awareness of sin would later become central to his art.

In 1494 Piero and Michelangelo were reconciled, and the artist was invited back into the Medici household. Within a few months, though, both men were forced to flee the palace and Florence after Piero foolishly allied the city with France in King Charles VIII's war against Naples. An angry Florentine mob, believing that Piero had betrayed them to the French, declared the city a Republic and stormed the palace. Piero escaped and died in exile nine years later; Michelangelo, concerned about his own safety due to his association with the Medicis, prudently went to Bologna. He remained there for a year, during which time he was commissioned to complete the sculptural decorations on the city's cherished tomb of Saint Dominic, a work that had already been in progress for well over a century.

By the end of 1495 the political climate in Florence had quieted, and Michelangelo was able to return to that city without fear. He was soon commissioned to sculpt a statue of John the Baptist, the city's patron saint, a work that has since been lost. He did not receive further commissions, however, so he left Florence and went to Rome, where he lived for the next five years. It was there that he created one of his greatest works: the *Pieta of*

St. Peter's. His contract for the *Pieta*, dated August 26, 1498, included a guarantee that the young sculptor's interpretation of the Virgin Mary mourning over the dead body of Christ would be "the finest work in marble which Rome today can show, and that no master of our days shall be able to produce a better . . ." Michelangelo more than fulfilled this expectation; the *Pieta* is one of the most beautiful marble pieces in the world. It also made its artist famous at the tender age of twenty-four.

Meanwhile, back in Florence, an enormous slab of pure white unflawed marble, nicknamed the "Giant," had suddenly become the talk of the town. Measuring eighteen feet in length and weighing several tons, it had been abandoned by another sculptor thirty-five years earlier and had since sat in the workyard of the city's cathedral. Piero Soderini, Florence's new leading citizen, agreed with the cathedral's Board of Works that it was time to award it to a new artist. As soon as Michelangelo heard the news, he hurried to Florence to present his own plan for the prized piece of marble. His proposal won, and on a September morning in 1501 he began work on his magnificent statue of David the Giant Killer in a shed specially built for the purpose. Three and a half years later, *David* was ceremoniously paraded through the narrow streets of Florence to the Palazzo Vecchio — a move that took four days, forty men, and fourteen giant rollers to accomplish. At the unveiling of the statue, Michelangelo was acclaimed the greatest sculptor in all of Italy.

David was not the only project occupying Michelangelo during this period. He had begun another work, one that pitted his genius against that of the other great artistic mind of the Renaissance — Leonardo da Vinci. Both men had been asked to design and paint a fresco for the Grand Council's hall in Florence's Palazzo della Signoria. Michelangelo had chosen the Florentines' victorious 1364 battle with the English cavalry of Sir John Hawkwood as his subject; Leonardo had chosen the 1440 Battle of Anghiari, in which the Florentines had routed a superior force of Milanese soldiers. Unfortunately, however, neither man produced a finished painting, and the cartoons the two did complete — the full-scale drawings on heavy paper of the battle scenes — were eventually torn into pieces and lost.

Michelangelo had a good reason for never beginning to paint his fresco: an imperious summons from the Pope himself. Julius II was a brilliant, demanding man whose plans for rebuilding Rome clearly reflected his own driving ambition. On hearing of Michelangelo's reputation, he insisted that the artist join him in Rome, and over the next eight years he proved to be both a valuable friend and a frustrating foe. He first put Michelangelo to work on his tomb. Initially it was thought that the project would take no more than four years to complete, but it ended up haunting the artist for four decades.

3

Julius also commissioned Michelangelo to paint the ceiling of the Sistine Chapel. Arguing that he was a sculptor and not a painter, Michelangelo tried to extricate himself from the commission, but this only made the strong-willed prelate more determined to have his way, and Michelangelo finally acquiesced. Working essentially alone, he completed the great fresco in four years. The Pope often climbed the scaffolding to impatiently prod him on — once quite literally with a cane. The chapel was finally opened for public viewing on October 31, 1512. This was sooner than Michelangelo had intended, but not too soon for the Pope, who died four months later at the age of sixty-nine.

At the request of Julius's family, Michelangelo went back to work on his tomb. But the project was again interrupted, this time by the new Pope, Leo, who was the son of Michelangelo's old mentor, Lorenzo de' Medici. The Medici family had returned to power in Italy; not only had they captured the papacy, but they had also reestablished their preeminence in Florence. Leo enlisted Michelangelo to design and build a façade for the Medici family church in Florence. The project consumed Michelangelo for three years but ended in failure. Delays in obtaining marble and other materials caused Leo to lose patience with Michelangelo until finally, in March of 1520, the Pope canceled the contract — an act Michelangelo considered "a very great insult." The façade was never built. Instead Leo put Michelangelo to work inside the church, ordering him to design and sculpt a new mausoleum and memorial chapel for the tombs of his father, uncle, and recently deceased brother and cousin.

During the next seven years Michelangelo worked intermittently on the Medici chapel, Julius's tomb, and a third large (and ultimately unfinished) project commissioned in 1524 by Pope Clement VII, one of Leo's cousins and his successor to the papacy. Clement asked Michelangelo to design a library in Florence that would house the great Medici collection of classical and early Christian manuscripts, and the artist dove into the project with his usual enthusiasm. Not long afterward, however, a series of events occurred that eventually culminated in Michelangelo's ceasing to work on the Medici library and leaving Florence forever.

In 1527 the Spanish army of King Charles V invaded and looted Rome. The Sistine Chapel became an army stable. Pope Clement fled the city, but he was quickly captured and imprisoned. When news of the sack of Rome reached Florence, the people of that city took advantage of the Medici family's weakened position and declared Florence a Republic, as they had first done thirty-three years earlier. The Medicis once again went into exile — but not for long. Repentent of the atrocities committed by his army and dis-

4

mayed at the loss of the papacy's dignity, King Charles made peace with Clement, who then gathered his own forces and set about regaining control of Florence. The Republic held out for ten months, but finally the Florentines were starved into submission. Clement proclaimed his bastard nephew Alessandro (who may even have been his bastard son) the new duke and ruler of Florence, and the Republic collapsed.

Despite his dislike of politics and his long-standing allegiance to the Medici family, Michelangelo had supported the Republican cause. During the siege of Florence he had even served as the new government's "Governor and Procurator-General over the construction and fortification of the city walls." Following the fall of the Republic, Clement decided to forgive Michelangelo for his earlier disloyalty and allowed him to return to work on the Medici mausoleum and library. He also asked him to sketch a design for a fresco of the Resurrection, which the Pope wanted painted over the altar in the Sistine Chapel.

Alessandro, the new duke, was not so benevolent. A brutish, tyrannical man, he openly despised Michelangelo. The artist realized that the Pope's favor was all that protected him from Alessandro's wrath, so when it became apparent in September of 1534 that Clement was dying, Michelangelo wisely left Florence. He never returned to that city — even after Alessandro was murdered in 1537.

Michelangelo spent the remaining thirty years of his life in Rome. Some of these were the happiest he had experienced since his youth. This was due in large part to the fact that he was able to form two close friendships during this time: one with a handsome young nobleman named Tommaso dei Cavelieri, to whom Michelangelo wrote most of his love poems, and the other with Vittoria Colonna, a middle-aged poetess and liberal Catholic intellectual to whom Michelangelo owed the deep religious sentiments of his final years. These sentiments are evident in the *Last Judgment*, which Michelangelo began painting in 1536 at the request of Pope Paul III. This enormous fresco, which stretches over the altar of the Sistine Chapel, took six years to complete — two more than the ceiling. Its message was so powerful that the Pope fell to his knees at its unveiling.

Still to come, however, was Michelangelo's greatest spiritual challenge: the design and construction of St. Peter's Cathedral. By now old, weary, and profoundly religious, he took on this project "solely for the love of God," refusing any payment. Although he made an immeasurable contribution to this great symbol of the Renaissance, he did not live to see its completion. Just before five o'clock in the afternoon on February 18, 1564, one month short of his eighty-ninth birthday, Michelangelo Buonarroti died. He

had caught cold a few days earlier while riding horseback in the rain. His body, as he had requested, was taken home to Florence. His pupil and friend, Giorgio Vasari, described his funeral in these words: "The next day all the painters, sculptors, and architects assembled quietly, bearing only a pall of velvet rich with gold embroidery. This they placed over the coffin and the bier. At nightfall they gathered silently The oldest and most distinguished masters each took a torch, while the younger artists at the same moment raised the bier. Blessed was he who could get a shoulder under it! All desired the glory of having borne to earth the remains of the greatest man ever known to the arts."

THE DRAWINGS OF MICHELANGELO

Inscribed in relief on Michelangelo's tomb in Florence are three interlocking crowns symbolizing painting, sculpture, and architecture. The emblem is a fitting one for the great master's tomb, for during his lifetime Michelangelo himself had used three circles for his mark. According to his pupil and biographer, Giorgio Vasari, the artist believed that the three disciplines of painting, sculpture, and architecture were "interdependent and linked in such a way that one emerged from the other, transferring profit and honor, linking up to such an extent that it is impossible and even forbidden to separate them."

Vasari, who is best known for his book *Lives of the Painters, Sculptors and Architects,* designed the emblem for Michelangelo's tomb. He also founded the Drawing Academy of Florence, a model for all future fine-arts academies. When it opened in 1563—one year before Michelangelo's death—the artist was unanimously elected "chief master and father of all."

This honorary title reflected the awe and respect with which Michelangelo's contemporaries viewed his drawing abilities. But *disegno,* or "drawing," meant more in Renaissance Italy than it does today. It was a skill thought to be inspired by God, a revelation of the "thought of God," as explained by the Venetian Antonio Dori in his 1549 book, *Disegno.* The artist, therefore, was seen as God's interpreter, a person elevated above all those to whom God had not given the talent to grasp and express His thoughts. With this in mind, it is easy to understand how Michelangelo, whose drawing

skills were so obviously inspired beyond those of any other artist in his day, came to be called "The Divine Michelangelo" during his lifetime.

Drawing was also perceived as having a practical side, however. In words attributed to Michelangelo: "The drawing . . . is the source and basis of painting, sculpture and all other artistic endeavor, the common base for all sciences." He was also quoted as arguing that it should not be done "with gold and silver or over-refined colors, but simply with a pen, a lead pencil, or a brush, in black and white." To him, color was a secondary element. He went so far as to reproach the Venetian school of art, especially the great Venetian painter Titian, for championing color over drawing.

Michelangelo also believed that drawing had to be done quickly in order for the artist to faithfully depict the inner vision revealed at the moment of God's grace. In spite of the rivalry that existed between the two men, it is likely that Michelangelo agreed with his contemporary, Leonardo da Vinci, who once instructed his students to "sketch the subject rapidly and don't finish the limbs altogether; only indicate their disposition." Leonardo also suggested that artists follow the example set by poets. "Have you never thought about the way a poet writes verse?" he asked. "He cares little about forming perfect letters and does not hesitate to scratch out several lines so as to improve them." He further maintained that the artist should continue to make corrections in a drawing for as long as the creative emotion lasted—and then stop.

According to the ideals of Renaissance art, then, a drawing was considered most authentic at its sketching rather than its final stage. The sketch, not the polished work, was what represented the moment of divine inspiration. It only followed that the sketches of an especially inspired genius like Michelangelo would be valued more highly than all the other treasures in the world. Such was the message sent to the artist by the mischievous sixteenth-century satirist, Pietro Aretino, who wrote: "But why, venerable master, do you not recompense me for all my devotion, I who bow before your divine greatness, by the gift of a few sheets that you value so little? I will certainly hold these few brush strokes on a bit of paper in greater esteem than all the cups and chains offered to me by princes."

Vasari claimed that Michelangelo never repeated a drawing but instead carried in his head all of the sketches he had ever made. Much of what Vasari wrote about Michelangelo, to whom he dedicated his *Lives*, must be read a bit skeptically, however, for it often echoes known anecdotes concerning other artists. He reported, for example, that in his youth Michelangelo copied and falsified drawings by ancient masters: "[H]e covered them with a patina which he made with smoke and by other means, so that they

might appear old and blackened. Set against authentic drawings, they were not distinguishable." Vasari may have told this story to enhance Michelangelo's mystique, for in Renaissance Italy an artist who could create a successful imitation was highly regarded. It seems unlikely, though, that Michelangelo tampered with his drawings, although some scholars do believe that he carved and weathered a sleeping Cupid during the slow winter of 1496 and then shipped it to Rome to have it sold as an antique. Later, after learning from the statue's buyer of the huge profit his Roman agent had made on the transaction, Michelangelo reportedly went to Rome and forced the agent to buy back the statue.

The story of how Michelangelo discovered his agent's deception is a revealing one. The sleeping Cupid's buyer, Cardinal Raffaello Riario, had traced the statue to Michelangelo through his drawings. Just as the ancient Greek painter Protogenes was able to recognize the work of his rival Apelles from a single line, so also was the great and unique genius of Michelangelo visible even in his quickest sketches. Ascanio Condivi, another of Michelangelo's pupils and biographers, recounted the Cupid episode in this way: "This gentleman [the Cardinal's envoy], pretending to be on the lookout for a sculptor capable of executing certain works in Rome, after visiting several, was directed to Michelangelo. When he saw the young artist, he begged him to show some proof of his ability, whereupon Michelangelo took a pen . . . and drew a hand with such grace that the gentleman was stupefied. Afterward, he asked if he had ever worked in marble, and when Michelangelo said yes, and mentioned among other things a Cupid of such height and in such an attitude, the man knew that he had found the right person."

Michelangelo's skill at sketching is given further credence in a story told by Giovanni Battista Armenini, another of his contemporaries. Armenini once described an incident in which a young Italian nobleman handed Michelangelo a piece of paper and asked him to draw Hercules standing: "So Michelangelo took this sheet, retired beneath a small shelter where there was a bench, put his right leg on the bench, rested his elbow on his knee, leaned his head on his right hand and, after a moment's reflection, began the drawing which he shortly finished; he then motioned for the young man to approach, and handed him the paper." The figure was so detailed and perfect, claimed the awe-struck Armenini, that most other artists would have required at least a month in which to complete it.

Michelangelo began each new drawing by outlining the contour of a figure. Once this line was defined, he filled in the interior features—those shaped by underlying muscles and bones. More subtle details were indicated by series of parallel lines or crosshatchings. This method of

working from the exterior to the interior of a figure was similar to the one he used when sculpting.

During the early stages of his artistic career, Michelangelo started most of his drawings in charcoal. When he was satisfied with these initial lines, he would go over them with a pen and then erase the charcoal marks. In moments of particularly powerful emotion he would reach for his pen first, especially when sketching a figure for a three-dimensional project. After red and black chalks were introduced into Florence during the first decade of the sixteenth century (probably by Leonardo), he also used these, seeming to find them most suitable for drawings intended as preparatory exercises for paintings. Most of the drawings for the Sistine Chapel ceiling fresco and the *Last Judgment*, for example, were done in chalk.

Michelangelo's drawing technique was greatly admired by his contemporaries. As Pietro Aretino wrote, "[Michelangelo] was, in our century, the first to place before the eyes of painters beautiful contours, foreshortenings, relief of volume, movement, and all that it takes to suggest the perfect image of the nude." The master did, however, have his detractors. He was criticized for painting figures that looked too much alike and for painting giants rather than people of ordinary stature. Aretino himself once noted, somewhat maliciously, that "if you have seen one figure of Michelangelo's you have seen them all." In comparing Michelangelo and Raphael, Aretino left no doubt as to where he stood: "Considering all the elements which a painter is expected to assimilate, we notice that Michelangelo possesses only one, namely drawing, whereas Raphael puts them all into play, or at least most of them."

M ichelangelo's nudes stand as eloquent testimony that the artist knew his anatomy. As an old man he recounted how, some sixty years earlier, he had given the prior of the Monastery of Santo Spirito in Florence a wooden crucifix in gratitude for allowing him to dissect cadavers in the Monastery's hospital. He performed another dissection in 1550 on the body of a perfectly-proportioned black man. Michelangelo never pursued this activity with the same fervor as did Leonardo da Vinci, however. And, except for one whose authenticity is questioned, none of the drawings Michelangelo made from his dissections has been preserved.

Three of Michelangelo's cartoons are extant, though (plates 51 and 57). During the Renaissance, the word *cartoon* had a very different meaning than it does today. Its etymological source is the Italian word *cartone*, meaning heavy paper. In Michelangelo's time, a cartoon consisted of

many sheets of paper which, when pasted together into a single large sheet, revealed a full-scale composition which would later be painted on a wall. Cartoons came into use during the middle of the fifteenth century, replacing the ancient technique of drawing directly onto a freshly plastered wall. Each figure in the cartoon was transferred to the plaster by means of a series of steps. First the paper was perforated along the outlines of the figures; then the paper was held up to the wall; and finally charcoal was dusted over it. The artist used the resulting charcoal outlines as guides. Michelangelo further simplified this process by tracing the outlines of his figures directly onto the soft plaster with a pointed engraving tool.

After drawing their cartoons, many painters (including Vasari) allowed their assistants to trace the figures onto the walls and even to paint them, telling them only what colors to use. Michelangelo's standards were so high, however, that he often dismissed his assistants and performed all of the steps himself—as he did in the case of the Sistine Chapel ceiling.

Renaissance artists believed that the study of drawing opened the door to success in all the arts, especially painting. Because sculptors often worked without drawings, painting was touted as the superior art form. Vasari, for example, condescendingly wrote about sculptors who "are not very experienced in tracing lines and contours, and consequently cannot draw on a sheet of paper and other surfaces," but who can, nevertheless, "[bring] out in relief, in clay or wax, the beautiful and proportionate figures of men and animals or other objects." Michelangelo, of course, disagreed vehemently with those who praised painting over sculpture, claiming that drawing skills were necessary for both.

To Michelangelo, sculpture was a lamp which illuminated painting. He compared sculpture to the sun and painting to the moon and considered the former to be a liberating act carried out by a privileged hand. Although eventually he was to proclaim the two art forms equal, he implied his preference for sculpture in many of his sonnets. In one, written after the deaths of his father and one of his brothers, he wrote: "Memory paints me a portrait of my brother and carves your [his father's] living image in my heart." He turned to sculpture to depict his strongest metaphors.

Michelangelo believed that painting and sculpture demanded different approaches on the part of the artist. "By sculpture," he once wrote, "I mean an art which one exercises by removing, while the art which is accomplished by adding resembles painting." According to this definition, sculptural drawings are those that give an impression of matter flying off under energetic "blows" of the pen—just as matter flies from a block of marble when it is struck by a hammer and chisel. "Pictorial" drawings, on the

11

other hand, are those which incorporate imaginary matter: lines seem to float lightly around the nucleus of a spiritualized body without ever quite defining it. The drawings of Michelangelo's later years may be termed "pictorial": more unfinished and less concerned with anatomy, they reveal a disdain for beauty and harmony. One of the artist's most impressive drawings of this type is the *Study of a Crucifixion* (plate 55), which Michelangelo may have been preparing for the tomb of his cherished friend, Vittoria Colonna.

In his early years Michelangelo had espoused Neoplatonism, a philosophy which, in part, held that all visible things were imperfect copies of their Ideal Forms and that it was the artist's duty to extract these Forms. As he wrote in a sonnet dedicated to Vittoria Colonna: "[T]he greatest of artists will not invent an image which is not already inscribed in the marble; it is only this image which the hand obedient to the spirit will free. . . ." And again: "Lady, just as a living figure lies in waiting in the rough stone, and the more one strikes the matter, the more this figure grows from it, so the vulgar bark of the body hides good qualities in a trembling soul. . . ."

Extracting the Ideal Form often meant disregarding conventional reality. "It is necessary to keep one's compass in one's eyes," Michelangelo said, "and not in the hand, for the hands execute, but the eye judges." Thus while the Virgin in the *Pieta of St. Peter's* is larger than life, the Christ Child she holds is not, even though their heads are equal in size and the two figures appear to be in proportion to each other. The same is true of a later Pieta drawing which Michelangelo dedicated to Vittoria Colonna (plate 48).

There are two groups of drawings, both executed as studies for his pupils, that occupy a special place in Michelangelo's oeuvre. The first is called the "divine heads" because that was the descriptive term initially given them by Vasari. These remarkable drawings in red chalk and charcoal were drawn with the intention of instructing two of Michelangelo's young friends, Gherado Perini and Tommaso dei Cavalieri. Those meant for Perini are only known through copies, but a handful of the ones drawn for Cavalieri survive in their original forms.

If one chooses to look for proof of Pietro Aretino's assertion that all of Michelangelo's figures are alike, one is apt to find it in these "divine heads." The artist intended them to be feminine, as is indicated by their hairstyles or adornments, but a male adolescent modeled for most if not all of them (see, for example, plates 38 and 39). Like Michelangelo's muscular female statues of *Dawn* and *Night* in the Medici Chapel, they suggest that beauty is an ideal undifferentiated by sex. This search for a sort of intersexuality did not stem from the artist's alleged homosexuality but rather from the Platonic ideal of an androgynous society.

The "divine heads" were not the only drawings Michelangelo made for Cavalieri. He also sent him many allegorical sketches, including the *Punishment of Tityos* (plate 34). This drawing symbolizes the suffering Michelangelo experienced because of his feelings for Cavalieri. It tells the story of Tityos, a young Titan whose burning passion for Leto, the mother of Apollo and Diana, resulted in his being sent to the underworld. There he spent eternity nailed to a rock while a vulture daily devoured his liver. On January 1, 1533, Cavalieri, who was then ill, wrote to Michelangelo to thank him for the *Punishment of Tityos* and to tell him that he would eagerly await the other drawings the master had promised him. "Until that time," he wrote, "I will enjoy your drawings for at least two hours, since the more I gaze at them, the more I like them. And the hope of knowing your other works will do much to soothe my pain."

Michelangelo often asked Cavalieri to critique his drawings. After sketching the *Fall of Phaethon*, he wrote to his friend in anguish, asking him whether the version met with his approval. If it did not, the artist vowed, he would create a new one on the following day. Cavalieri must have voiced certain objections, for Michelangelo seems to have sketched two more *Falls* (plate 36).

In rendering his "divine heads," Michelangelo attempted to extract perfect beauty from imperfect models. In another group of rare drawings, he seems to have done the exact opposite: namely, emphasize the monstrous in the human form. In these caprices, or "ghiribizzi" (plates 22, 23, and 24), the grotesque noses, bulging eyes, and grimaces seem irreconcilable with the divine features of the figures in his other drawings. Consequently, art historians maintained for years that the "ghiribizzi" could not have been executed by him. In recent times, though, this critical view has changed. It is now believed that Michelangelo's monsters are consistent with his artistic principles in that they support the right of the artist to create new phenomena by combining elements of real beings. In keeping with this most recent theory, it is interesting to note that the artist apparently felt that art created solely for recreation and the distraction of the senses could be just as legitimate as "serious" art.

With a single exception (plate 26), the drawings selected for inclusion in this volume demonstrate the ways in which Michelangelo interpreted the human figure. According to the master, this was the most noble subject in all of art. Due to space considerations, it has been necessary to ignore the vast collection of his architectural drawings, but this is not to be seen as implying that these are any less fascinating or important. Like other Renaissance artists, Michelangelo considered architecture to be closely related

13

to the study and representation of the human body because it, too, involved the creation of an organic totality.

M ichelangelo had mixed feelings about his own drawings. In 1506 he expressed great concern for them in a letter he wrote from Rome to his father in Florence: "I would like you to take all those drawings, that is all those papers that I put in that sack I told you about, and make a package and send them to me by a carter. But make sure you pack them well against water, and take care about the carter, so that the smallest paper does not take harm; and recommend the package to the carter, because there are certain things that are very important." Yet eleven years later, in 1517, he ordered all of the drawings in his Roman studio burned—among them, presumably, many of the same drawings for which he had previously evinced so much concern. Vast collections of his studies and cartoons were destroyed as a result of that tragic change of heart.

Michelangelo's decision to have his drawings destroyed should not be seen as indicating that he condemned his former style. In fact, he never negated his past. According to Vasari, Michelangelo was once shown a drawing he had done years earlier as an apprentice. After looking at it the artist claimed "that he knew more about drawing as a boy than he did now in his old age." Although this may be yet another of Vasari's fictional anecdotes about Michelangelo, it nevertheless reflects the artist's real view of his life's work.

In the last days of his life Michelangelo made yet another brutal decision about his drawings: he personally burned great quantities of additional studies and preliminary cartoons. Thus the detailed inventory of his work drawn up after his death listed only ten cartoons and a few drawings— much to the disappointment of Duke Cosimo I de' Medici, who had hoped someday to unearth the original plans for the unfinished library and tombs of the Medici chapel.

Why did Michelangelo destroy his drawings? For a very simple reason: he wanted to erase all evidence of his long and arduous search for perfection. He did not want anyone to see what to him were the tedious, imperfect pieces that preceded his finished works. He destroyed all of the wax and clay models he had built for his architectural projects for the same reason. Michelangelo believed that the completed work was the one that counted; preliminary efforts were meaningless. This is illustrated by another anecdote. He was once shown some sketches made by a famous sculptor and asked whether he recognized the hand of a great artist. In response, Michel-

angelo asked if any final works had evolved out of the sketches. When he was told that they had not, he emphatically exclaimed, "Then don't say that he is a great artist!"

It is difficult to ascertain why Michelangelo chose to destroy certain drawings and not others. Perhaps he kept some for nostalgic reasons. Others seem to have been preserved due to a practical and rather mundane consideration: paper was very expensive in sixteenth century Italy, and artists frequently turned old drawings over and drew on the backs of them. A large number of Michelangelo's drawings are covered on both sides, not only with other sketches but also with drafts of letters and poems and even with mathematical calculations. Just as he refined his drawings in long series of studies, he never ceased editing and rewriting his sonnets. And, like his drawings, early drafts of his sonnets often met with a fiery fate.

Many of Michelangelo's drawings were saved by friends who snatched them from destruction without his knowledge. Giorgio Vasari and Vicenzo Borghini in particular piously collected and preserved every line drawn by Michelangelo's hand that fell within their grasp. Had it not been for the efforts of these two men, only a few of the master's drawings would have survived to the present day.

Many of Michelangelo's extant drawings are ones that he generously gave to friends; the *Study for the Head of Leda* (plate V), for example, was a gift to his assistant Antonio Mini. He was especially generous to his friend and fellow artist Sebastiano de Piombo, whose laziness was legendary. Michelangelo often helped Sebastiano with his work, going so far as to draw sketches or cartoons for him. Often the drawings did not arrive quickly enough for Sebastiano. "I beg you," he wrote to Michelangelo in 1532, "not to forget to bring me the figures, legs, bust, and arms which I have wanted for so long and of which I have the audacity to remind you."

Once Michelangelo's drawings were the target of a pair of thieves. Vasari recounts the tale: "These boys had made their way into his house and, motivated more by love of art than any intention to cause harm, stole from his student Antonio Mini a great number of drawings; after an intervention by the Council of Eight, these were returned to Michelangelo who, thanks to the entreaties of his friend Giovanni Norchiati, Canon of San Lorenzo, did not impose any penalty on the thieves." It may have been better, however, had the drawings been kept out of Michelangelo's reach.

Art historians hesitate before attributing drawings to Michelangelo—for a number of very good reasons. It was a common practice among collectors of his drawings, especially Vasari, to restore worn portions themselves. In addition, studies and sketches done by the master were often

15

copied and sometimes even falsified. Among the works modified or altered by Michelangelo's students, only those executed by the unimaginative Mini are glaringly obvious. It is far more difficult to recognize the products of other imitators. This issue is made even more complicated by the fact that while some of these imitators are known by name, others remain anonymous. According to Vasari, an artist called Battista Franco once "decided to study and imitate the drawings, paintings, and sculptures of Michelangelo. And so he set out to seek them, until no sketch, model, or any other thing by the master survived without being drawn by him." Yet not a single copy has been attributed to Franco with certainty. Is it possible that some of the "authentic" Michelangelo drawings are the determined Franco's imitations?

Many artists copied Michelangelo's drawings in order to use the sketches as models for their own later works. Others, however, tried to pass off their copies as the originals. Such was the case of the Flemish artist Dionigio Calvaert, a gifted imitator of both Raphael and Michelangelo who worked in Rome after 1570. His bogus renderings of Michelangelo's fresco studies were in great demand after the master's death.

It seems unlikely that scholars will ever be in complete agreement as to how many drawings by Michelangelo have actually survived. Research in this field has resulted in several vastly disparate opinions and theses. Luitpold Dussler, for example, cites only 243 drawings as "authentic," while Frederick Hartt cites 537. Although Hartt's list seems audaciously broad, it nevertheless represents a new, unprejudiced approach. So we have included in this collection several drawings whose authenticity is considered problematic by Dussler and his followers but defended by Hartt.

CATALOGUE

21

STUDIES OF MALE NUDE AND DRAPED WOMEN, about 1501–1503
Pen; 10⅜ x 15¼"; cut down
Chantilly, Musee Conde (29 recto)

Although these figures appear together on the same sheet, this is not a compositional drawing. The two female nudes to the right and left of the robed figure were probably inspired by the central nude in the Roman frieze of the *Three Graces* located in the Piccolomini Library of the Cathedral of Siena; Michelangelo must have seen the frieze when he was in Siena in 1501. It remains unclear, however, as to what inspired the drawing of the male nude at the left.

—I—

STUDIES FOR TWO STATUES OF DAVID, probably 1501–1502
Pen; 10½ x 7⅜"; cut down
Paris, The Louvre (714 recto)

The arm at the center of the sheet was undoubtedly drawn from a live model and was used as a study for the right arm of Michelangelo's marble *David*. The full study of David at the left was made for a smaller bronze statue commissioned on August 12, 1502 by Pierre de Rohan, marshal of France. At the right Michelangelo has written, "David with the slingshot and I with the bow" (the bow probably refers to a tool used by stonecutters), and "Broken is the high column, the green . . . ," a fragment from the first verse of a Plutarchan sonnet on the deaths of Laura and Cardinal Colonna.

—4—

STUDIES OF A MALE NUDE DIGGING, A MALE NUDE
HALF-FIGURE SEEN FROM THE BACK, AND SHOULDERS,
about 1501–1502
Pen; 10½ x 7⅜"; cut down
Paris, The Louvre (714 verso)

The figure of a man digging was inspired by Jacopo della Quercia's *Adam Digging* on the portal of San Petronio in Bologna, the city to which Michelangelo fled in 1494. The head, which seems to swirl up from the nude half-figure, creates an eerie effect. The verse written in Michelangelo's hand at the top reads: "To the sweet murmur of a little river, which descends slowly from the green shadow of a clear spring." This verse is not found elsewhere among Michelangelo's poems; nor is it known why these studies were executed.

—5—

STUDY FOR THE MADONNA TADEI, AND SELF-PORTRAIT
OF MICHELANGELO, about 1501–1502
Pen; 11¼ x 8¼"; cut down
Berline-Dahlem, Staatliche Museen, Kupferstichkabinett (1363)
This drawing, whose authenticity has often been questioned, probably represents Michelangelo's first complete study of a head from a live model. Between the Madonna and the Christ Child, directly above the Child's upraised left arm, can also be seen the anxious face of a man—apparently the artist's self-portrait.

—6—

STUDY FOR THE FRESCO OF THE BATTLE OF CASCINA, 1504
Silverpoint and black chalk; 9¼ x 14"; cut down
Florence, Uffizi (613 E recto)
This is one of the few extant sketches made by Michelangelo as a study for a major section of a painting; most of his other compositional sketches were destroyed by his own hand. According to reliable surviving copies, several of the figures on this sheet also appeared in the final cartoon of the *Battle of Cascina*.

—7—

MERCURY HOLDING A VIOL, YOUNG MAN HOLDING AN AMPHORA, 1505
Pen; 15¾ x 8¼"; cut down
Paris, The Louvre (688 recto)
The two-winged hat worn by the larger figure seems to identify him as Mercury, but the lightly sketched viol he holds so hesitantly is reminiscent of Apollo. The 1505 date given this drawing by Frederick Hartt is based on additional sketches found on its reverse, including that of a bound man—perhaps an early idea for one of the figures for Pope Julius II's tomb.

—8—

MALE NUDE STANDING, about 1505
Pen; 13⅜ x 6⅝"; cut down
Paris, The Louvre (R. F. 70-1068 recto)
This drawing seems to hint at the influence of an unknown classical statue. It evokes a strange tension that eventually found its way into the figures of slaves that Michelangelo executed on the tomb of Julius II.

MALE NUDE, RIGHT ARM, SKETCH FOR HEAD OF AN OLD MAN, 1505
Pen; 13⅜ x 6⅝"; cut down
Paris, The Louvre (R. F. 70-1068 verso)
Although this drawing has been linked to the crucified *Haman* on the Sistine Chapel ceiling, it seems more likely that it was a preliminary study for the *Chained Slave* of Julius II's tomb. The head of the old man appears to be a preliminary sketch for the *Moses* also found on the tomb. The masculine arm at right was probably a study for the unfinished statue of *Saint Matthew* which Michelangelo carved during 1506 and 1507. Among the words which the artist wrote on this sheet are the following from Dante's *Inferno:* "Gather them together at the foot of the wretched mound."

ST. ANNE AND THE VIRGIN AND CHILD, MALE NUDE,
CARICATURED HEAD, about 1505
Pen with brown and gray ink over black chalk; 12¾ x 10¼"; cut down
Paris, The Louvre (685 recto)
This drawing seems to be a sketch for an unfinished relief called the *Pitti Madonna* after the man who commissioned it, Bartolommeo Pitti. Pitti had originally asked for a Madonna and St. Anne, but Michelangelo chose to embellish this idea. The influence of Leonardo da Vinci's *Madonna and St. Anne* is quite evident in this drawing, although Michelangelo treated this subject in a notably different manner.

STUDY OF TWO WARRIORS FOR THE FRESCO OF THE BATTLE
OF CASCINA, about 1504
Pen and black chalk with touches of white; 10½ x 7⅝"
Vienna, Albertina (S. R. 157 recto)
This sheet undoubtedly belongs to the group of studies for the lost *Battle of Cascina* cartoon. Some historians doubt its authenticity, but their arguments are not convincing.

STUDY OF A WARRIOR FOR THE FRESCO OF THE BATTLE OF CASCINA,
1504 or 1506
Black chalk with touches of white; 7 ⅝ x 10½"; cut down
Vienna, Albertina (S. R. 157 verso)
Few scholars now doubt that this drawing was executed by Michelangelo, although some believe that it was later retouched by an unknown hand.

STUDY OF COMBAT FOR THE FRESCO OF THE BATTLE OF CASCINA,
about 1504
Pen; 7 x 9⅞"; cut down
Oxford, Ashmolean Museum (P. 294)
This active, energetic battle scene was sketched for the lost cartoon of the *Battle of Cascina*.

STUDY OF A SEATED WOMAN, PROBABLY FOR THE ACTIVE LIFE-LEAH
STATUE ON THE TOMB OF JULIUS II, 1505-1506
Red chalk and pen with brown ink; 16 x 11"; cut down
London, British Museum (1887-5-2-115 recto)
Although Luitpold Dussler disputes the claim that Michelangelo sketched this drawing, its style seems to suggest a connection between it and studies made by the artist for the tomb of Julius II during the months of 1505 and 1506. An echo of this figure's pose can be seen in the tomb's *Active Life-Leah*, a statue Michelangelo carved for the tomb forty years after this drawing was made. The architectural sketches seen here were executed on the sheet's reverse side and are not related to the study.

STUDY FOR THE HEAD OF THE NUDE ADOLESCENT AT LEFT
ABOVE THE PROPHET ISAIAH ON THE SISTINE CEILING, 1508
Black chalk with touches of white; 12 x 8¼"
Paris, The Louvre (860 recto)
Despite the reluctance of some scholars to attribute this delightful study of a smiling youth to Michelangelo, it appears to be an authentic example of his work.

STUDY OF ADAM FOR THE SCENE OF ADAM AND EVE'S EXPULSION FROM PARADISE ON THE SISTINE CEILING, 1510
Black chalk; 10 ½ x 7 ½"
Florence, Casa Buonarroti (45 F)

The authenticity of this light sketch of Adam. which only a few critics regard as a copy, seems to be proved by the very fact that it differs from the final version— thus revealing a mind engaged in creating, not copying.

STUDIES OF LEFT HAND AND MALE TORSO FOR THE SISTINE CEILING, 1508, 1509, 1510
Pen and black chalk; 9⅞ x 14¼"; cut down
Detroit Institute of Arts (27.2 recto)

This drawing depicts one of the stages in Michelangelo's overall design for the Sistine Chapel ceiling. The male torso seems to be a study for one of Noah's sons in the *Sacrifice of Noah;* the left hand is either a study for Adam in the *Creation of Adam* or, more likely, a study for the nude adolescent that appears to the left above the *Cumaean Sibyl.* On the back of this drawing are more studies for the sibyls.

STUDIES FOR THE CRUCIFIED HAMAN ON THE SISTINE CEILING, 1511
Red chalk; 10 x 7 ½"; cut down
Haarlem, Teylersmuseum (A 16 recto)

Although in the past some scholars have doubted this drawing's authenticity, Frederick Hartt and others have more recently reinstated it among the works of Michelangelo. Its high artistic value is indisputable.

STUDY OF THE CRUCIFIED HAMAN FOR THE SISTINE CEILING, 1511
Red chalk; 16 x 8¼", cut down
London, British Museum (1895-9-15-497 Malcolm n. 60 recto)

The many details of this drawing which differ from those found in Michelangelo's final version on the Sistine Chapel ceiling confirm its authenticity, although a few scholars still insist that it is a copy.

STUDIES OF ADAM'S RIGHT KNEE AND OF THREE ANGELS
FOR THE CREATION OF ADAM ON THE SISTINE CEILING, 1511
Red chalk over black chalk; 11⅝ x 7¾"; cut down
Haarlem, Teylersmuseum (A 20 verso)
This sheet's authenticity has been rigorously contested, but the expressive power of line in these sketches clearly reveals the hand of the master.

STUDY FOR THE YOUNG MALE NUDE AT RIGHT ABOVE THE
PERSIAN SIBYL ON THE SISTINE CEILING, 1511
Red chalk over black chalk; 11 x 8⅜" cut down
Haarlem, Teylersmuseum (A 27 recto)
This sheet belongs to a highly contested group of drawings. It may have been re-touched by another artist, yet it betrays Michelangelo's characteristic style.

STUDY FOR THE YOUNG MALE NUDE AT LEFT ABOVE THE
PERSIAN SIBYL ON THE SISTINE CEILING, 1511
Red chalk with touches of white; 10⅝ x 7½"
Vienna, Albertina (S.R. 155 recto)
The authenticity of this drawing, like so many of those done by Michelangelo for the Sistine Chapel ceiling, has often been contested in the past. Today, however, it is generally considered one of the most beautiful examples of the master's art.

STUDY OF A PUTTO AND OF THE RIGHT ARM OF THE LIBYAN SIBYL
ON THE SISTINE CEILING, SKETCHES OF SLAVES FOR THE TOMB
OF JULIUS II, 1511 and 1513
Red chalk and pen; 11¼ x 7⅝"
Oxford, Ashmolean Museum (P. 322)
The Sistine studies of the putto and arm undoubtedly date from 1511. The lighter sketches of the six bound slaves were probably added to the sheet in 1513, the year in which Michelangelo signed his second contract for Julius's tomb. The cornice shown in the top left corner is the same as that found on the lower story of the tomb.

STUDY OF THE LIBYAN SIBYL FOR THE SISTINE CEILING, 1511
Red chalk; 11 ¼ x 8 ⅜"; cut down
New York, Metropolitan Museum (24.197.2 recto)
The central figure on this sheet is almost universally considered to be one of the most precious testaments to Michelangelo's genius as a draftsman. Some scholars have attributed other details on the sheet to Michelangelo's students; because the tone of these details is the same as that of the half-figure of the Sibyl, however, it seems more likely that all of the sketches were created by the same hand.

—22—

ST. COSMAS, about 1517–1518
Pen over black chalk; 13 x 7 ½"
Oxford, Ashmolean Museum (P. 324)
Luitpold Dussler believed this to be a sketch of a beggarwoman; Frederick Hartt, on the other hand, contends that it is a male figure dressed in the robes of a doctor. Hartt argues that Michelangelo sketched it as a study of either St. Cosmas or St. Damian for the façade of the Medici chapel in Florence, a project that never came to fruition. The two saints were patrons of the Medici—and doctors. Hartt documents his hypothesis convincingly.

—23—

STUDY OF A MAN'S HEAD, possibly 1517–1518
Red chalk; 6 ⅛ x 4 ⅞"
Oxford, Ashmolean Museum (P. 322)
This expressive, powerful profile is considered by Frederick Hartt to be a study of the head of St. Damian for the ill-fated façade of the Medici chapel in Florence. If that is true, then it was probably drawn during those months in 1517 and 1518 when Michelangelo was working on the façade's design. Hartt's hypothesis, however, leaves one serious question unanswered: why would Michelangelo treat a martyr who was venerated by the Medici family in such an exaggerated fashion?

PROFILE OF A YOUNG MAN WEARING A BERET, possibly 1517-1518
Red chalk; 11⅛ x 7¾"
Oxford, Ashmolean Museum (P. 316 recto)

This drawing, like *St. Cosmas* (plate 22) and *Study of a Man's Head* (plate 23),
belongs to Michelangelo's "ghiribizzi," or caprices—works in which he seems to
relax into deformity and hyperbole as if fatigued by his lifelong quest for superhu-
man beauty. Historians have searched in vain for a meaning or purpose to this
drawing. It seems chronologically related to *St. Cosmas* and *Study*, which is why it
is dated 1517-1518.

—25—

STUDY FOR CHRIST RESURRECTED, possibly 1517-1518
Black chalk; 13 x 7¾"
Florence, Casa Buonarroti (66 F)

Frederick Hartt believes that this drawing may have been the first in a group of
studies for a Resurrection scene that Michelangelo intended to carve in relief over
the central door of the Medici chapel façade. Luitpold Dussler, on the other hand,
attributed it to one of Michelangelo's students. It seems likely, however, that this
drawing was sketched by Michelangelo as a study of Christ floating in the air, for
there is a more finished version of the same pose at the British Musuem that is
generally recognized as belonging to the master.

—26—

DRAGON (SALAMANDER?), about 1517-1518
Pen over black chalk; 10 x 13¼"
Oxford, Ashmolean Museum (P. 323 recto)

It appears that Michelangelo may have intended to decorate the bases of some of
the statues of the Medici chapel façade with salamanders, creatures who were once
thought capable of living in fire. One prime candidate for such a base was the
statue of St. Lawrence, who, according to legend, was reborn in flames to eternal
life. The salamander would also have been appropriate for the façade because it
was the heraldic beast of King Francis I of France, who the Medici family hoped to
someday link to their family through marriage. Michelangelo made several sala-
mander drawings, of which this is the most finished.

STUDY FOR THE LEFT HAND OF GUILIANO DE' MEDICI
ON HIS TOMB IN THE MEDICI CHAPEL, 1520–1521
Pen; 11½ x 10¾"
Florence, Archivio Buonarroti (XIII, fol. 169 verso)

The hand of the finished statue of Guiliano on Julius II's tomb holds a few coins; this drawing seems to indicate that the coins were not in Michelangelo's original plans for the statue. The lines of text that appear on this drawing were written on its reverse.

STUDY FOR THE HEAD OF DAWN IN THE MEDICI CHAPEL,
about 1520–1521 or possibly later
Red and black chalk retouched with pen; 13 x 8½"
London, British Museum (1895–9–15–498 Malcolm 61 recto)

This purely sculptural drawing of the head of *Dawn* is justly considered to be the work of Michelangelo, although some historians believe that it was reworked later by Sebastiano del Piombo, one of the master's pupils. The unfinished hand in the foreground is a preliminary sketch for the right hand of *Guiliano de' Medici*. It is unclear whether Michelangelo made this drawing while he was studying figures for the statues (1520–1521) or while he was actually doing the sculpting (after 1524).

STUDY OF THE RESURRECTION FOR THE LUNETTE ON THE
ENTRANCE WALL OF THE MEDICI CHAPEL, 1520–1525
Black chalk; 9½ x 13⅝"; cut down
Windsor, Royal Library (12767 recto)

Some scholars have doubted the purpose of this explosive drawing of Christ leaping from his grave. Yet its semicircular shape would have fit perfectly into the lunette on the entrance wall of the Medici Chapel—a structure which was, after all, dedicated to the Resurrection.

HEAD OF A FAUN, possibly 1524-1531
Pen over red chalk lines; 11 x 8¼"
Paris, The Louvre (684 recto)

Although some scholars doubt this theory, it seems likely that the energetic pen strokes in this drawing were executed by Michelangelo over a sketch of a female head with long braids drawn in red chalk by his ungifted student Antonio Mini. Less convincing, however, is Frederick Hartt's contention that Michelangelo intended this to be a giant's head rather than that of a faun. He bases his hypothesis on an enigmatic poem by Michelangelo that talks of a giant so large that he could crush a city with one foot and overlooks the obvious faun-like characteristics of the drawing.

—31—

CRUCIFIXION (THREE CROSSES), probably after 1521
Red chalk; 15½ x 11"
London, British Museum (1860–6–16–3)

Why Michelangelo made this sketch of the Crucifixion remains a mystery. It has been suggested—unconvincingly—that it was done as a study for an altar piece in the Medici Chapel.

—32—

THREE OF THE TWELVE LABORS OF HERCULES, possibly 1528
Red chalk; 10¾ x 16⅝"
Windsor, Royal Library (12770)

Both in its technique and its meticulous execution, this drawing closely resembles the presentational drawings Michelangelo so generously gave to his friends later in his life. It is not known precisely why he made this drawing but, because Hercules was a hero of the Florentine Republic, it has been suggested that these three labors represent the three expulsions of the Medici family from Florence in 1433, 1494, and 1527. This is a particularly sensitive drawing, showing a delicate play of light balanced by a line that is both light and firm.

YOUNG SEATED WOMAN, probably between 1528 and 1534.
Pen and red and black chalk; 12¾ x 10¼"
London, British Museum (1859–6–25–547 recto)
Some historians have doubted this drawing's authenticity, but it is now generally accepted as a genuine example of one of Michelangelo's "divine heads." The figure's dress is related to the armor of the Dukes in the Medici Chapel.

THE PUNISHMENT OF TITYOS, 1532
Black chalk; 7½ x 13"
Windsor, Royal Library (12771 recto)
This drawing tells the ancient story of a young Titan called Tityos. He conceived a burning passion for Leto, the mother of Apollo and Diana, and as a result was sent to the underworld. There he was nailed to a rock for all eternity, and a vulture came daily to devour his liver (considered the site of human passion). The story held a symbolic meaning for Michelangelo, who suffered a Platonic and foolhardy passion for a young nobleman named Tommaso dei Cavalieri. Michelangelo sent this drawing to Cavalieri during the last days of 1532, and in return received a warm letter of thanks from his friend dated January 1, 1533. Although this drawing was made as a gift, Michelangelo sketched it on paper that he had used earlier for a Resurrection study.

STUDY FOR THE HEAD OF LEDA, 1529–1530
Red chalk; 14 x 10⅝"
Florence, Casa Buonarroti (7 F)
This exquisite head, although probably drawn from a live male model, was a study for the lost painting *Leda and the Swan*, a work which was commissioned by Alfonso d'Este and never delivered. It was not, as was once believed, a study for one of the figures on the Sistine Chapel ceiling. Michelangelo repeated the detail of the closed eye later in his life.

THE RESURRECTION, 1532–1533
Black chalk; 12 ¾ x 11 ¼ "; cut down
London, British Museum (1860–6–16–133)

This drawing, which was preceded by several similar studies made from a live model, was meant as a study for the *Resurrection*, a fresco commissioned by Pope Clement VII for the main altar of the Sistine Chapel. Scaffolding was erected in 1534, but the Pope died not long afterward and Michelangelo never even began the project. Later, at the request of Pope Paul III, he would paint *The Last Judgment* over the same altar. This figure of Christ floating up out of his grave expresses Michelangelo's spiritual evolution toward the asceticism of the Counter-Reformation.

THE FALL OF PHAETHON, 1533
Black chalk; 16 ¼ x 9 ¼ "; cut down
Windsor, Royal Library (12766 recto)

Michelangelo began sketching the *Fall of Phaethon* immediately after completing *The Punishment of Tityos* (plate 34). The legend of Phaethon, who was struck down by Jupiter's thunderbolt for having disobeyed his law, was seen by the artist as a metaphor for the punishment that he felt he was sure to experience as a result of his attachment to Tommaso dei Cavalieri. Michelangelo apparently sketched three versions of *The Fall*; this seems to be the final one. At the bottom of the first version he wrote a message asking Cavalieri to let him know whether he liked the drawing; if he did not, Michelangelo added, he would sketch another one on the following day.

A DREAM OF HUMAN LIFE, possibly 1533–1534
Black chalk; 15 ⅝ x 11"
London, Coll. Count Antoine Seilern

This drawing, considered a copy by many historians, is closely related to both *The Punishment of Tityos* (plate 34) and *The Fall of Phaethon* (plate 36). It, too, was apparently dedicated to Cavalieri and meant as a moral allegory. It depicts a winged Fame awakening a young man from his sinful dreams. In the half-circle of dream images can be seen six of the seven Cardinal Sins—only Pride is missing. The drawing suggests, therefore, that a strong desire for glory—or fame—can dispel the nightmares (masks) of the world (globe).

THREE-QUARTER VIEW OF A HEAD, 1533–1534
Black chalk; 8⅜ x 5⅝"
Windsor, Royal Library (12764 recto)

Although the authenticity of this wistful drawing has been disputed by some historians, it seems likely that it belongs to Michelangelo's "divine heads" of 1533–1534.

PROFILE OF A HEAD (VENUS?), about 1533–1534
Black chalk; 11¼ x 9¼"; cut down
London, British Museum (1895-9-15-493 Malcolm 56 recto)

The strangely fixed look of this face has caused many historians to doubt that Michelangelo drew it. Yet numerous little touches in it show the hand of the master; most likely he executed it as a model for his students. The winged head of Love that appears on the top of the headdress suggests that the artist intended this as the head of Venus.

STUDY FOR THE LAST JUDGMENT, 1534
Black chalk; 16½ x 11⅜"
Florence, Casa Buonarroti (65 F recto)

Many elements of this drawing can be found in the final version Michelangelo painted as part of the *Last Judgment*. The upper part of the study, in which the Virgin kneels before her son to intercede on behalf of humanity, can be seen as a metaphor for the artist's struggle with conception and form.

—41—

STUDY OF A MAN KNEELING, about 1534–1535
Black chalk; 10¼ x 6¼"
Florence, Casa Buonarroti (54 F)
This drawing seems related to the *Last Judgment;* perhaps it was a study for the figure of the demon kneeling before the abyss of Hell. Doubts about its authenticity have been dissipated rather convincingly by Frederick Hartt.

—42—

STUDY OF A FALLEN ANGEL FOR THE LAST JUDGMENT, about 1534–1535
Black chalk; 15¾ x 10⅝"; cut down
London, British Museum (1860-6-16-5 recto)
The various poses drawn here of a figure floating in the air can be found among the completed figures of the *Last Judgment.*

—43—

STUDY OF A MAN FOR THE RESURRECTION OF THE BODIES
IN THE LAST JUDGMENT, about 1534–1535
Black chalk; 8½ x 10½"; cut down
Oxford, Ashmolean Museum (P. 330 recto)
Some critics have been reluctant to attribute this drawing and the *Study of a Fallen Angel* (plate 42) to Michelangelo, yet the style and skill evident in both reveal the hand of the master.

—44—

STUDY FOR ST. LAWRENCE IN THE LAST JUDGMENT, 1534–1535
Black chalk; 9½ x 7¼"; cut down
Haarlem, Teylersmuseum (A 23 recto)
The figure on this sheet is almost identical to the final version Michelangelo painted in the Chapel. The head, however, was softened in the painting.

—45—

STUDY OF A MAN FOR THE RESURRECTION OF THE BODIES
IN THE LAST JUDGMENT, about 1534–1535
Black chalk; 11½ x 9¼"; cut down at the top
London, British Museum (1886-5-13-5 recto)

Despite its exceptional quality and the tentative contour lines that show a mind engaged in creating, not copying, this drawing's authenticity is often wrongly questioned.

—46—

STUDY OF A HALF-FIGURE OF THE DEAD CHRIST, probably 1534–1535
Black chalk; 10 x 12⅝"; cut down
Paris, The Louvre (716)

This drawing has frequently been attributed to Michelangelo's student, Sebastiano de Piombo. Although parts of the drawing (the leg and separate studies of the arms) are certainly Piombo's, the torso reflects Michelangelo's genius. Most likely he gave the study to Piombo, who then elaborated on it.

—VI—

THREE-QUARTER HEAD, possibly 1533–1534
Red chalk, 8 x 6½"
Oxford, Ashmolean Museum (P. 315)

This exquisite drawing is one of Michelangelo's "divine heads," a term first coined by Giorgio Vasari. Michelangelo created these drawings for two of his favorite students, Gherardo Perini and Tommaso dei Cavalieri, to exemplify the classical ideal of sublimated beauty.

—47—

STUDY OF A HALF-FIGURE OF A MAN (CHRIST?), RIGHT HAND,
probably 1534–1535
Black chalk; 15⅝ x 11"
Florence, Casa Buonarroti (69 F recto)

Although its authenticity is vigorously disputed, this drawing seems to have been executed by Michelangelo. Frederick Hartt suggests that it was a study for the *Last Judgment;* it seems more likely, however, that it was intended to be a figure study of a dead Christ, a hypothesis given credence by the ironic gesture of the left hand. This drawing is closely related to the *Study of a Half-Figure of the Dead Christ* (plate 46).

PIETA FOR VITTORIA COLONNA, about 1538–1540
Black chalk; 11⅝ x 7⅝"; cut down and badly damaged
Boston, Isabella Stewart Gardner Museum
The authenticity of this presentation drawing has been both disputed and defended. Yet we know from Michelangelo's two contemporary biographers, Ascanio Condivi and Giorgio Vasari, that he made such a drawing for his friend Vittoria Colonna. The inscription on the vertical beam of the cross is a quote from Dante's *Divine Comedy:* "No one thinks of all the blood that it costs."

GROUP OF WOMEN—FRAGMENT OF A DESCENT FROM THE CROSS.
1536–1540
Black chalk; 8⅜ x 5⅝"
London, British Museum (1860-6-16-4)
Although some scholars doubt this drawing's authenticity, others—including the cautious Luitpold Dussler—have declared it a bona fide Michelangelo.

STUDY OF SOLDIERS FOR THE CRUCIFIXION OF ST. PETER
IN THE PAULINE CHAPEL OF THE VATICAN, 1545
Black chalk; 6 x 4⅛"; cut down
Oxford, Ashmolean Museum (P. 331)
This is one of the few sketches drawn by Michelangelo for the frescoes of the Pauline Chapel that have survived to the present day. Its authenticity is denied by Luitpold Dussler but upheld by Frederick Hartt.

FACE OF A SOLDIER FROM A FRAGMENT OF THE CARTOON
OF THE CRUCIFIXION OF ST. PETER IN THE PAULINE CHAPEL
OF THE VATICAN, 1545
Black chalk with touches of white; cartoon consists of 19 sheets with a total size of
8'7½" x 5'1⅜"
Naples, Museo Nazionale di Capodimonte (398)
One of three surviving Michelangelo cartoons, this testifies to the master's precision.

SAMSON AND DELILAH, about 1540 or later
Red chalk; 10⅝ x 15½"; cut down
Oxford, Ashmolean Museum (P. 319)
Unlike other Old Testament drawings by Michelangelo, including *Jacob Wrestling with the Angel* (plate 53) and *The Sacrifice of Isaac* (plate 54), this one appears to have been completed by the artist himself, probably because he intended it as a gift. Some of the hard lines seen in the drawing have caused a few historians to label it a copy, but its overall high quality justifies its attribution to Michelangelo.

JACOB WRESTLING WITH THE ANGEL, probably about 1545–1550
Red chalk; 9⅝ x 7½"; cut down
Paris, The Louvre (709 recto)
This drawing, which develops another theme from the Old Testament, does not seem related to any of Michelangelo's finished projects—a trait it shares, in addition to style, with *The Sacrifice of Isaac* (plate 54). The drawing's authenticity is doubted by Luitpold Dussler and denied by others.

THE SACRIFICE OF ISAAC, probably about 1545–1550
Black chalk, red chalk, and pen; 16 x 11⅜"; cut down
Florence, Casa Buonarroti (70 F)
This sketch deals with yet another Old Testament theme and is generally attributed to Michelangelo.

STUDY OF A CRUCIFIXION WITH CHRIST PLACED BETWEEN
ST. JOHN AND THE VIRGIN, about 1550–1555
Black chalk; 11 x 9¼"
Oxford, Ashmolean Museum (P. 343 recto)
This drawing, which is generally attributed to Michelangelo, belongs to a series of Crucifixion sketches done by the artist late in his life when he was turning away from the Ideal Forms of Neoplatonism and embracing the religious mysticism of the Counter-Reformation.

STUDY FOR AN ANNUNCIATION, about 1555–1560
Black chalk; 11⅛ x 7¾"; cut down
London, British Museum (1895-9-15-516 Malcolm 78 recto)
Michelangelo's treatment of the Annunciation is in marked contrast to the tradition-
al approach that calls for the apparition of the Angel, Mary's visible surprise, and
the dramatic dialogue between the two. Here Mary appears in deep meditation (a
pose used for some of the sibyls on the Sistine Chapel Ceiling) as she listens to the
words of an invisible angel.

—56—

STUDY OF CHRIST CHASING THE MONEY-CHANGERS
FROM THE TEMPLE, possibly after 1550
Black chalk; 7 x 14⅝"; cut down
London, British Museum (1860-6-16-2/3)
This drawing was probably the last in a series of seven studies in which Michelange-
lo depicted the biblical story of Christ chasing the money-changers and dove-sellers
from the Temple. The purpose of these studies remains unknown, although Freder-
ick Hartt suggests that they were intended for a composition Michelangelo planned
for a lunette over the entrance to the Pauline Chapel.

—57—

HOLY FAMILY SURROUNDED BY SAINTS, probably 1553
Black chalk; cartoon consists of 25 sheets with a total size of 7'7¾" x 5'5⅜"
London, British Museum (1895-9-15-518 Malcolm 81)
One of three surviving cartoons by Michelangelo (see also plate 51), this was listed
after his death in the official inventory of his possessions. His pupil and biographer
Ascanio Condivi used the drawing as a model for one of his own paintings—a work
probably executed sometime during 1553, following the publication of his biogra-
phy of Michelangelo. It is difficult to determine the identity of the young male
figure at the left. Some scholars believe that it is the prophet Isaiah; others claim
that it represents St. Julian. The older figure at the right is undoubtedly that of St.
Joseph. The Virgin's gesture is also open to various interpretations. This drawing, in
which form and space are merged, is an excellent example of Michelangelo's later
style.

HEAD OF ST. JOSEPH FROM THE CARTOON OF THE HOLY FAMILY
SURROUNDED BY SAINTS, probably 1553
(See description of plate 57 above)

This sensitive head of St. Joseph in the *Holy Family* cartoon may have been an attempt at a self-portrait.

—59—

VIRGIN OF THE ANNUNCIATION, about 1550–1560
Black chalk; 13¾ x 8¾"; cut down
London, British Museum (1900-6-11-1 recto)

Toward the end of his life, Michelangelo returned to the theme of the Annunciation in a series of studies that typify his later style. Although he still began each drawing by outlining the contour of the figure, the line had now become evasive and did not imprison the figure. The atmosphere in this drawing seems to vibrate with the words of the Virgin and the Angel (of whom only a lightly sketched hand can be seen). If it was a study, however, it never led to a completed work by Michelangelo or any other artist.

—60—

STANDING VIRGIN AND CHILD, about 1560–1564
Black chalk; 10½ x 4⅝"; cut down
London, British Museum (1859-6-25-562)

This tender motif of maternal love seems to have marked the end of Michelangelo's artistic career.

THE PLATES

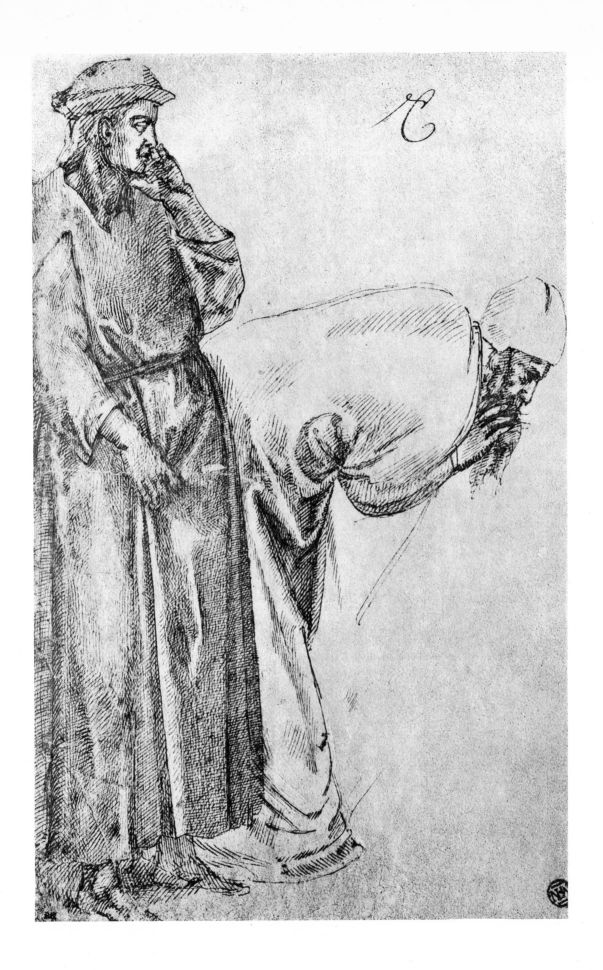

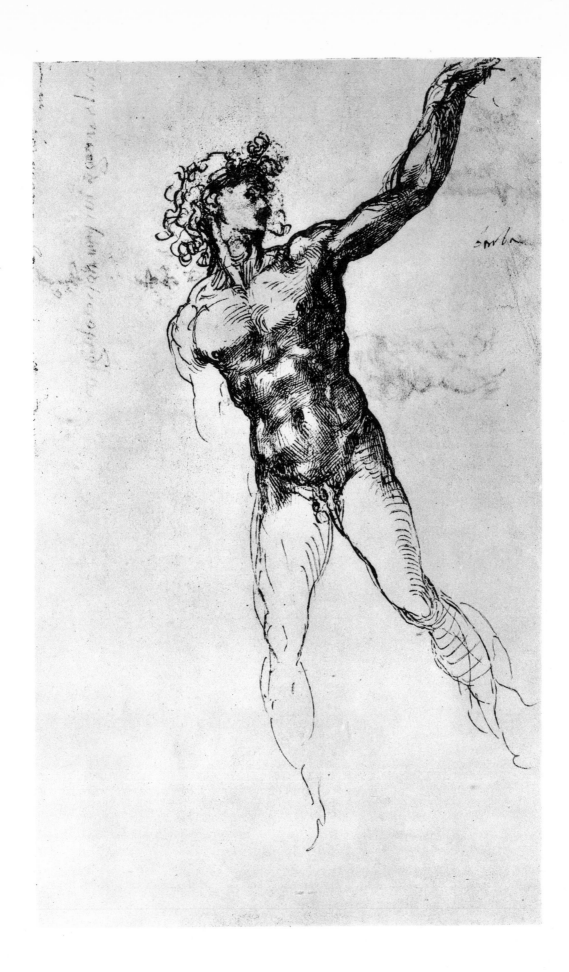

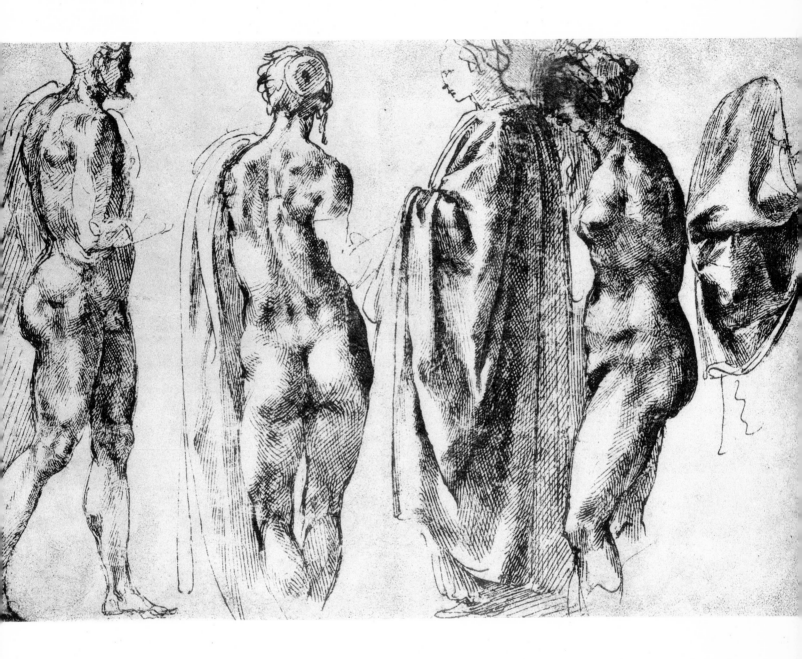

3

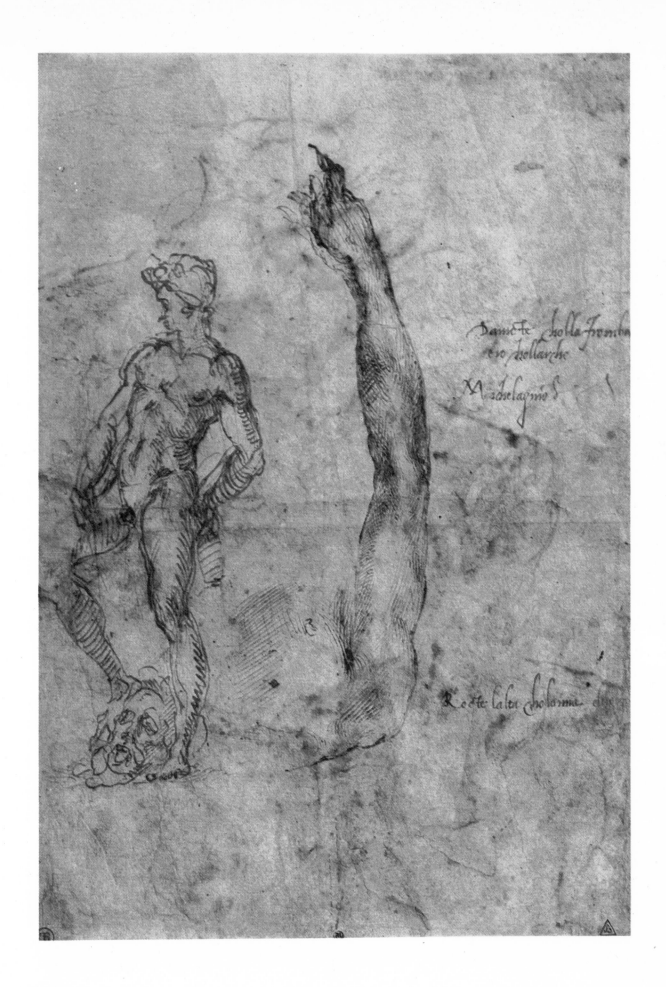

I

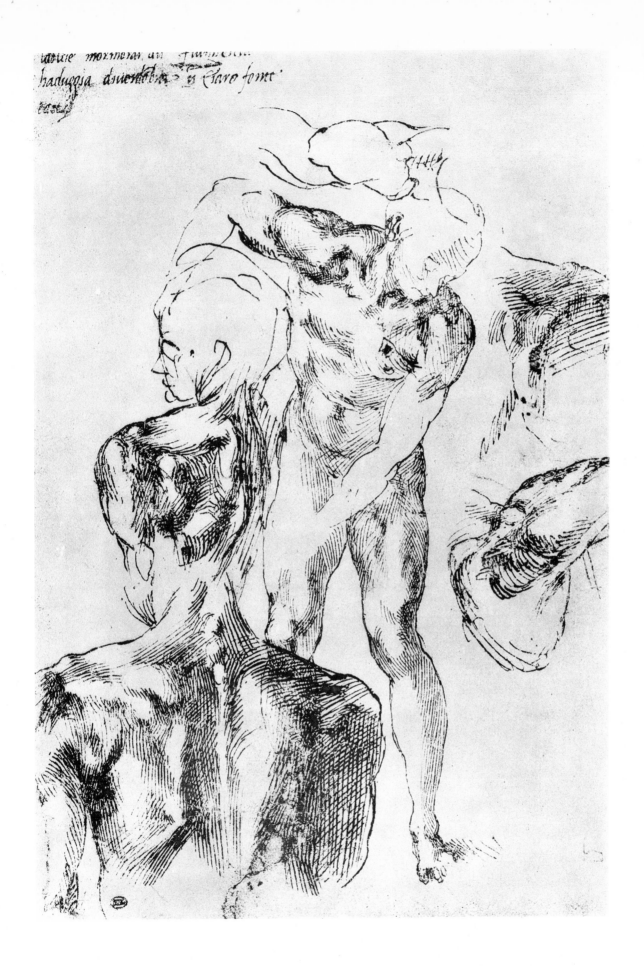

4

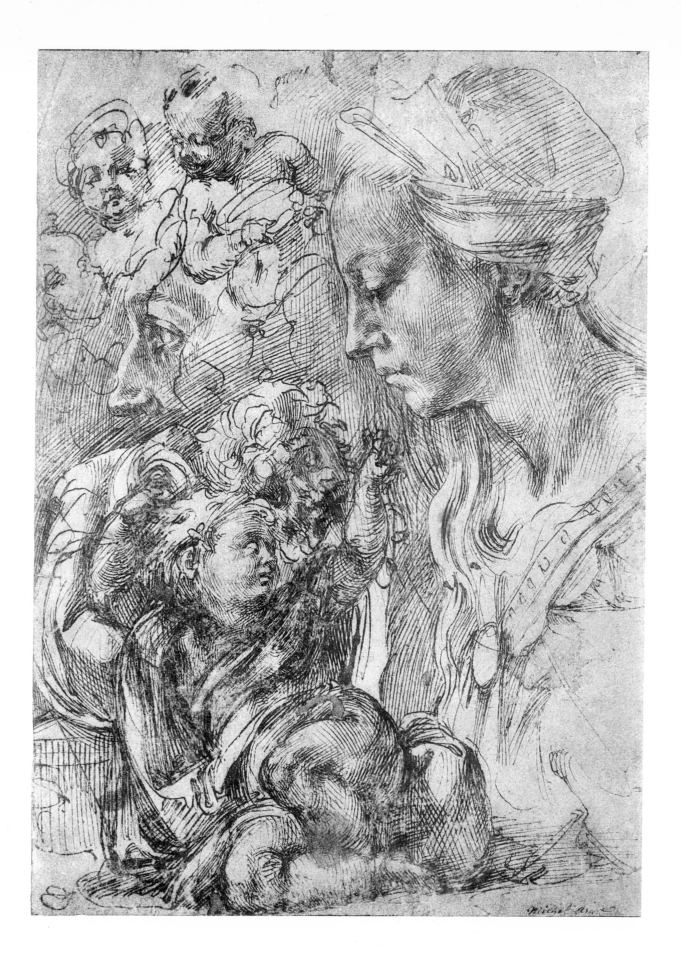

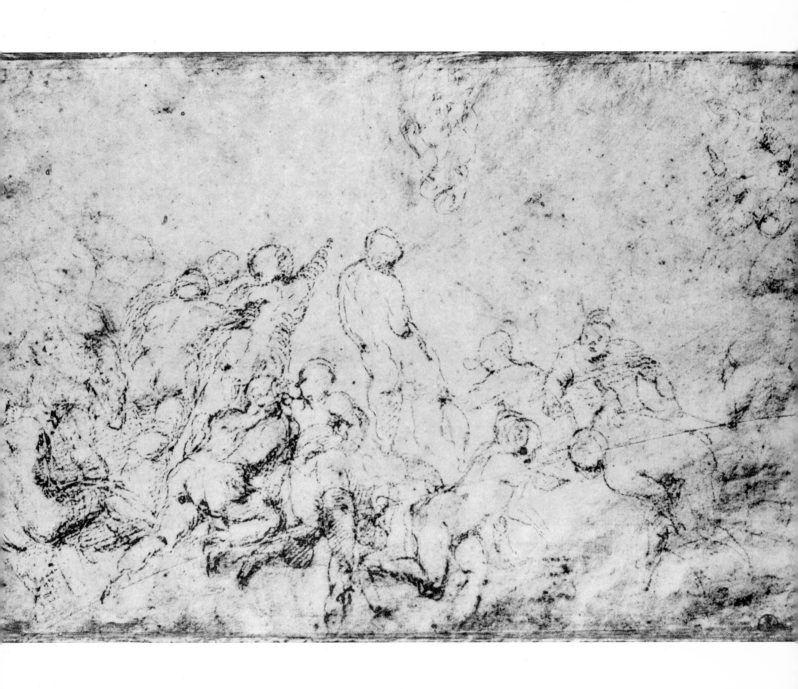

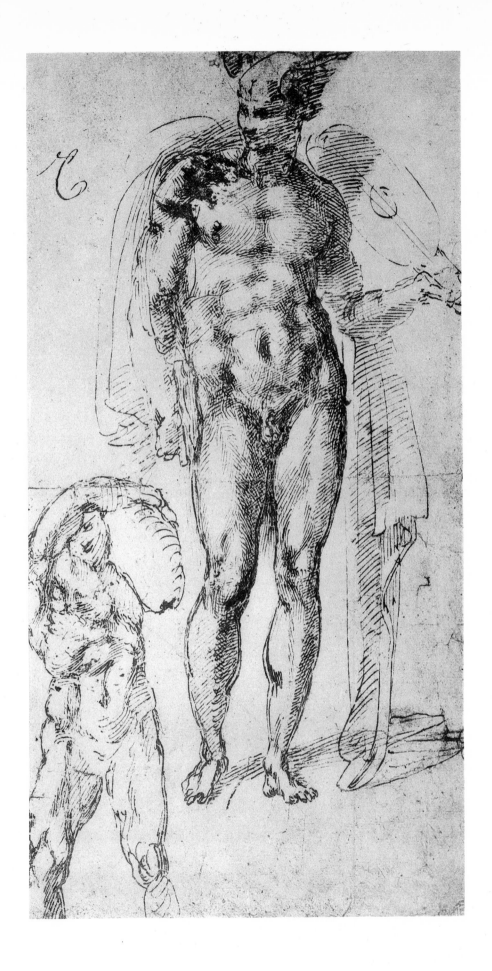

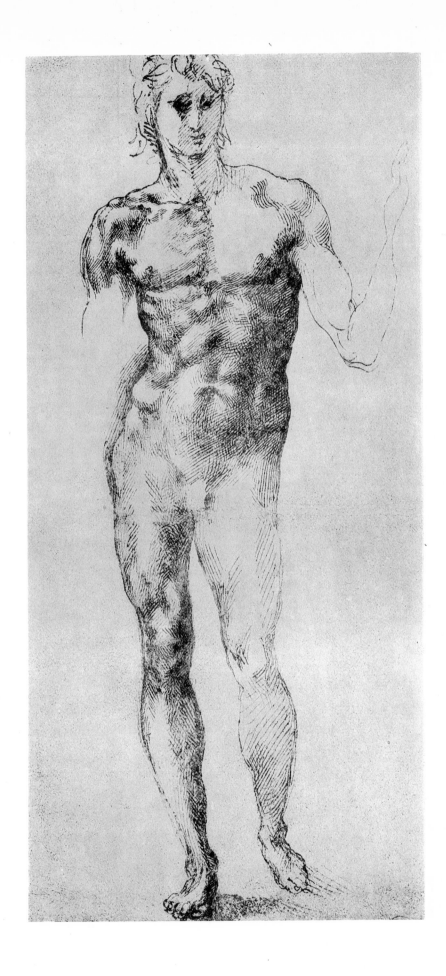

8

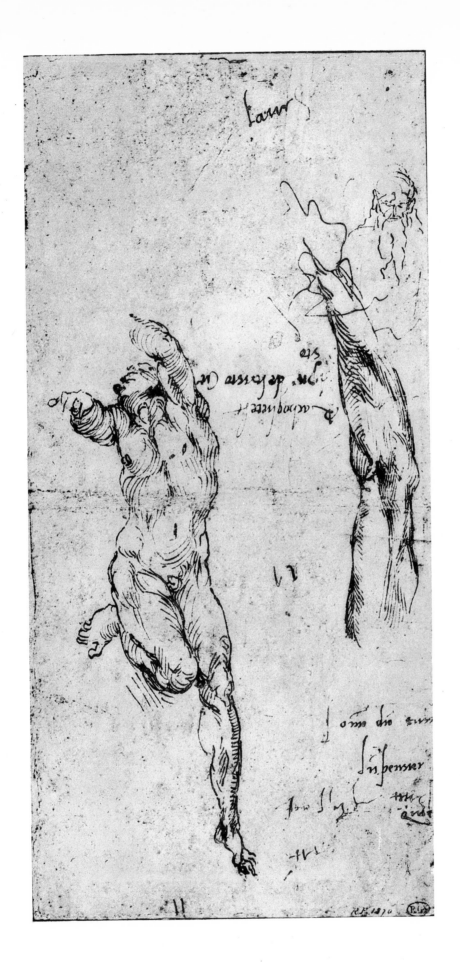

9

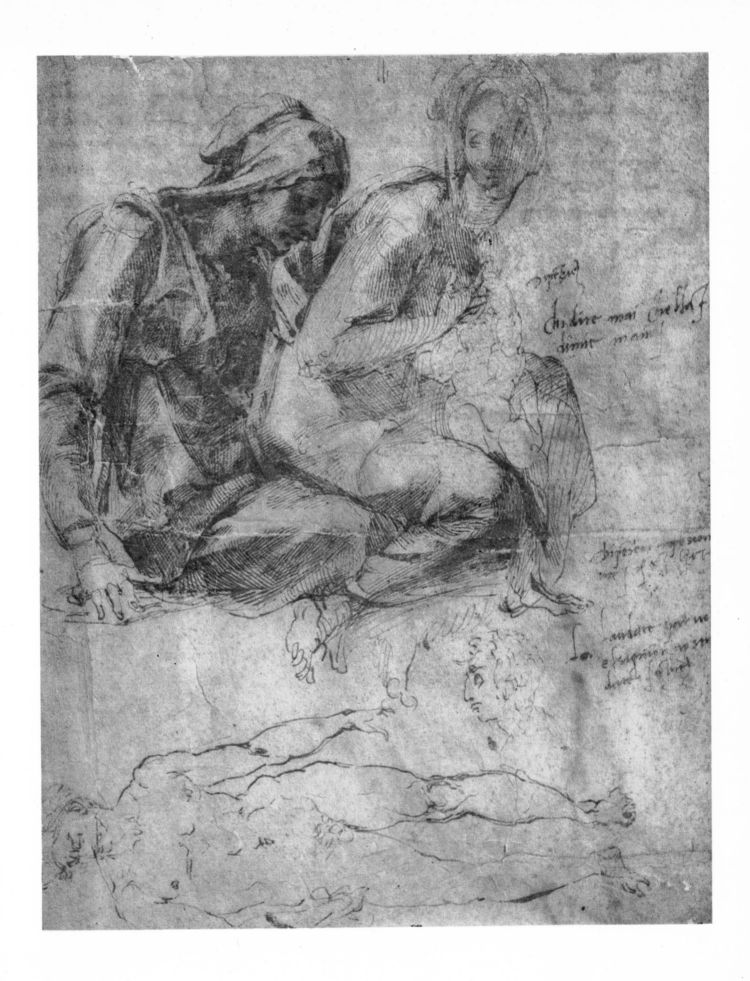

II

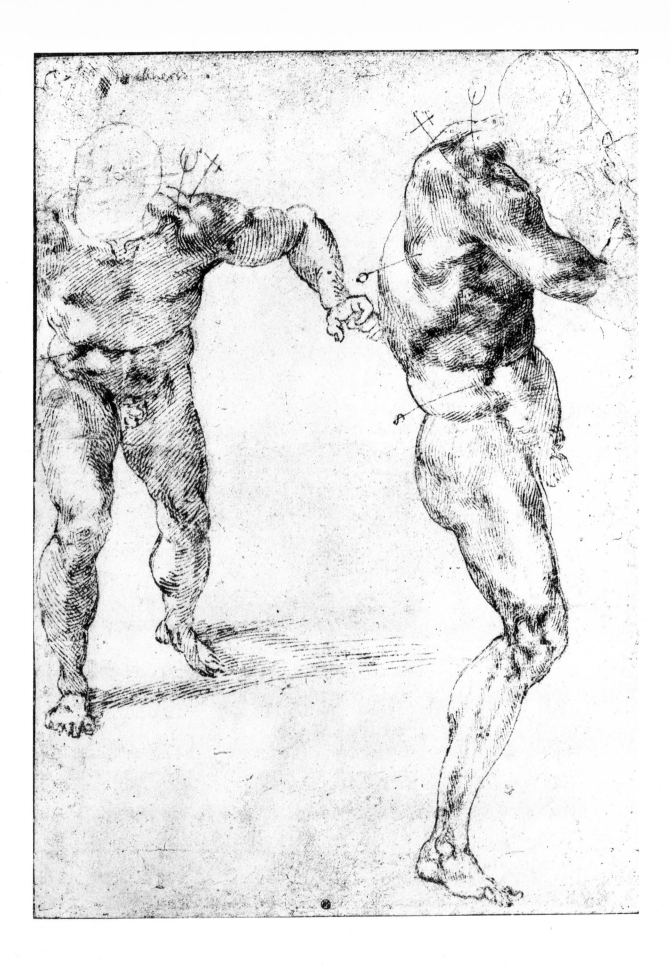

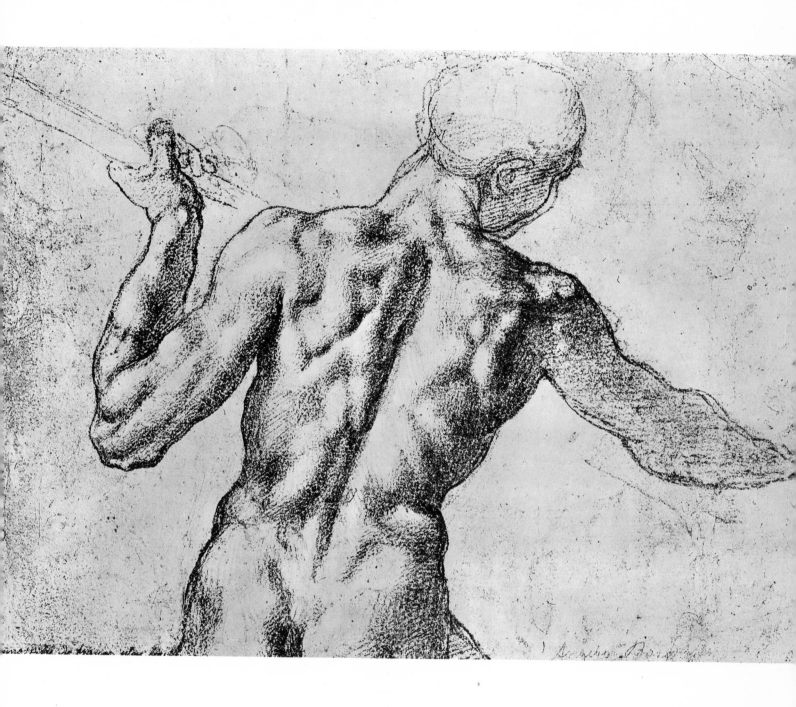

II

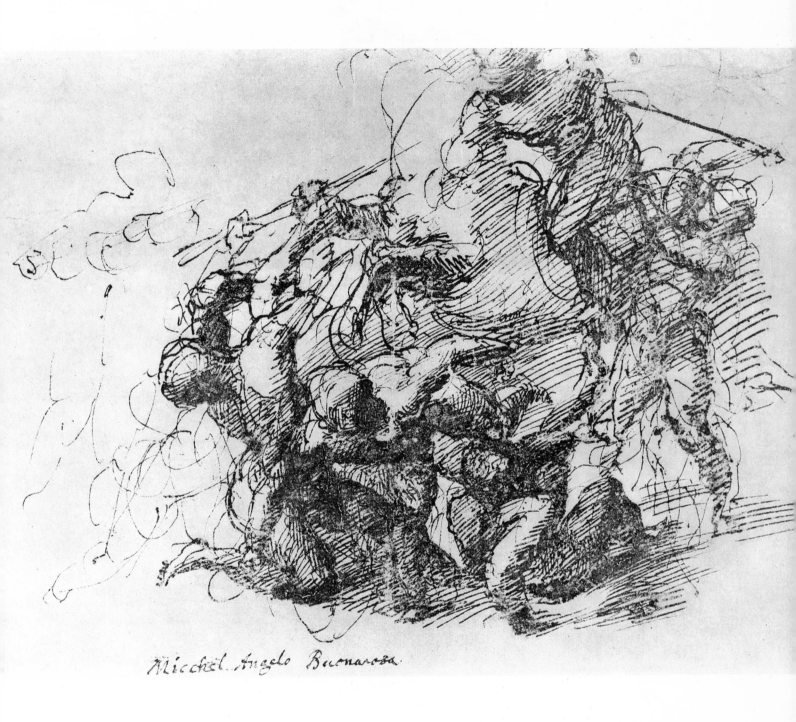

Micchel Angelo Buonarosa.

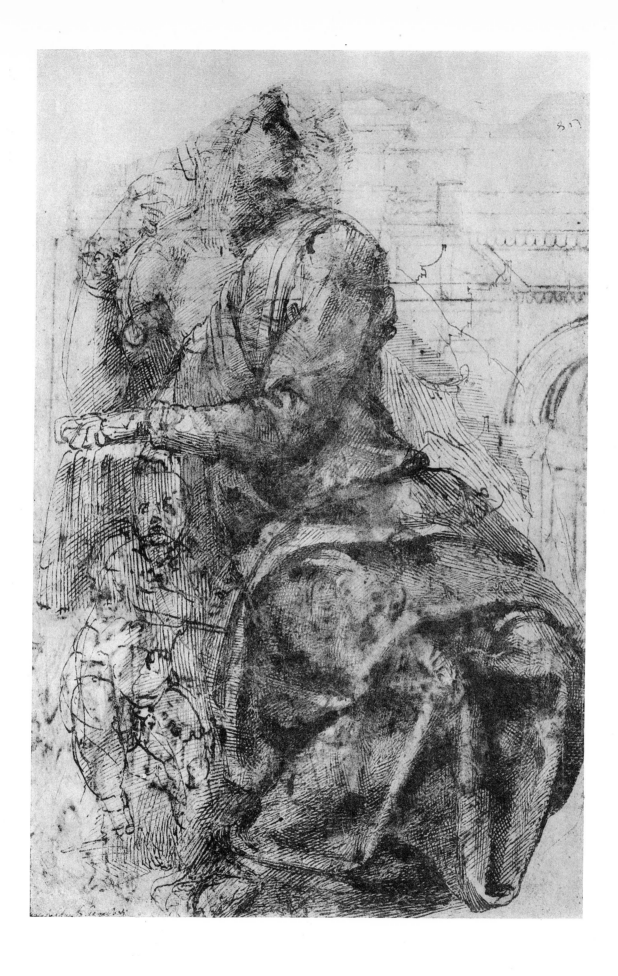

13

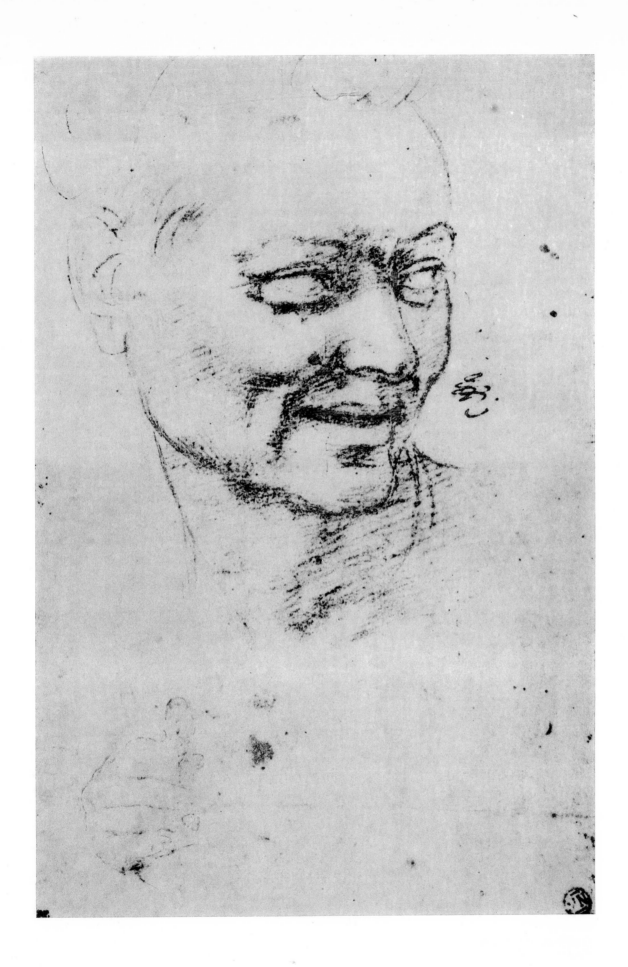

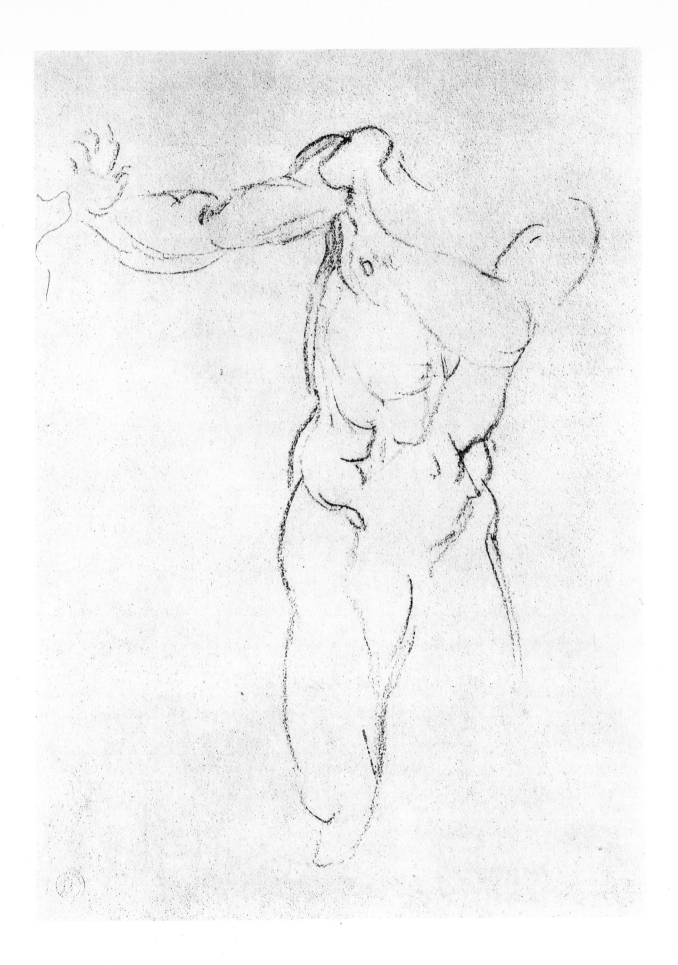

15

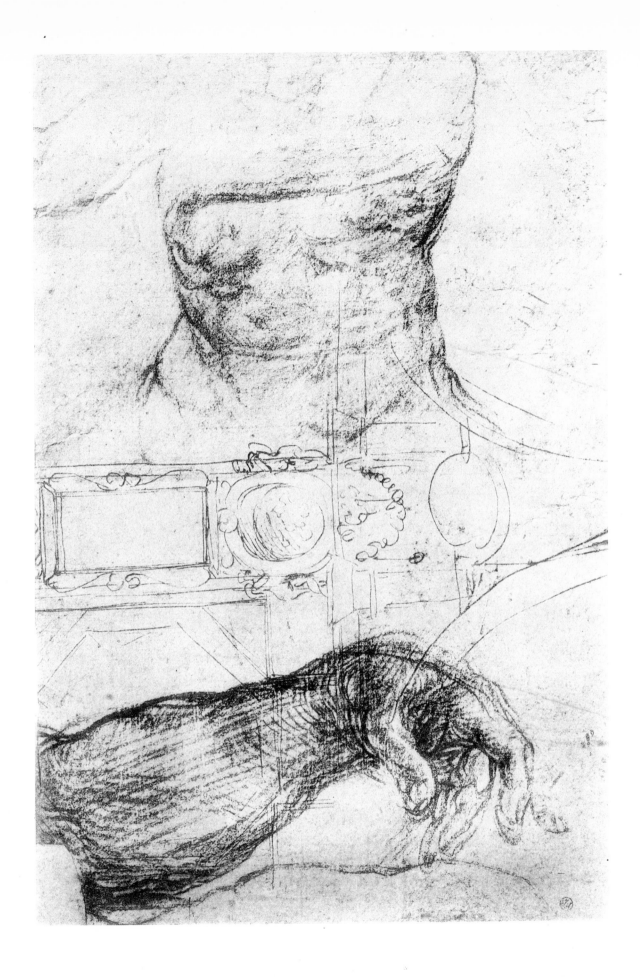

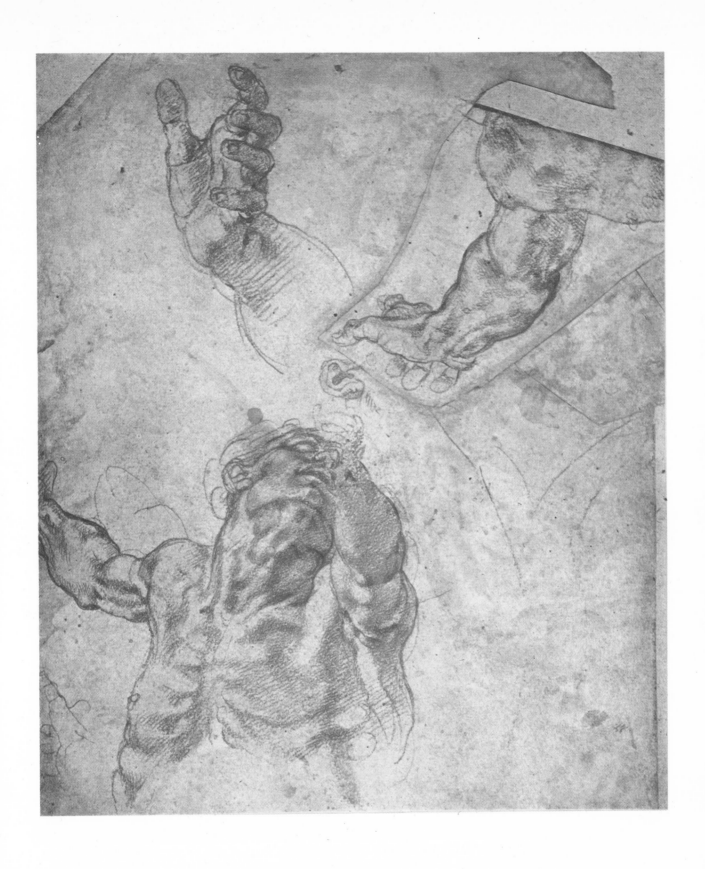

III

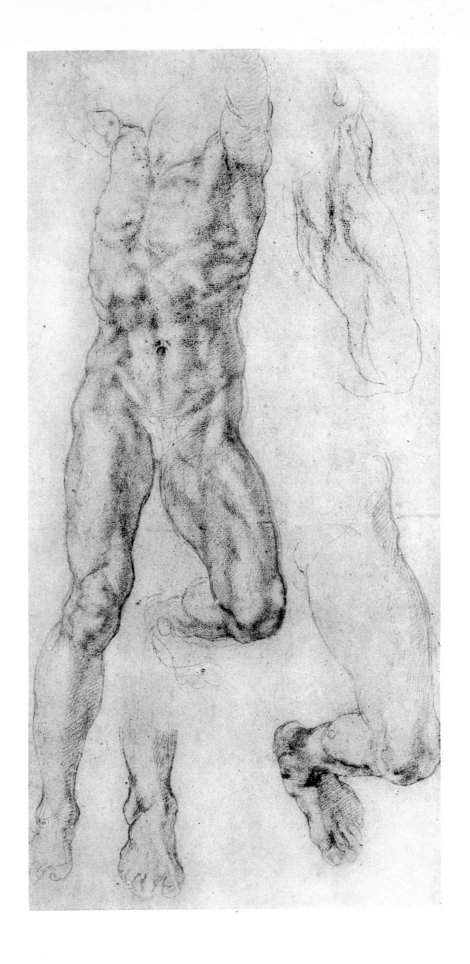

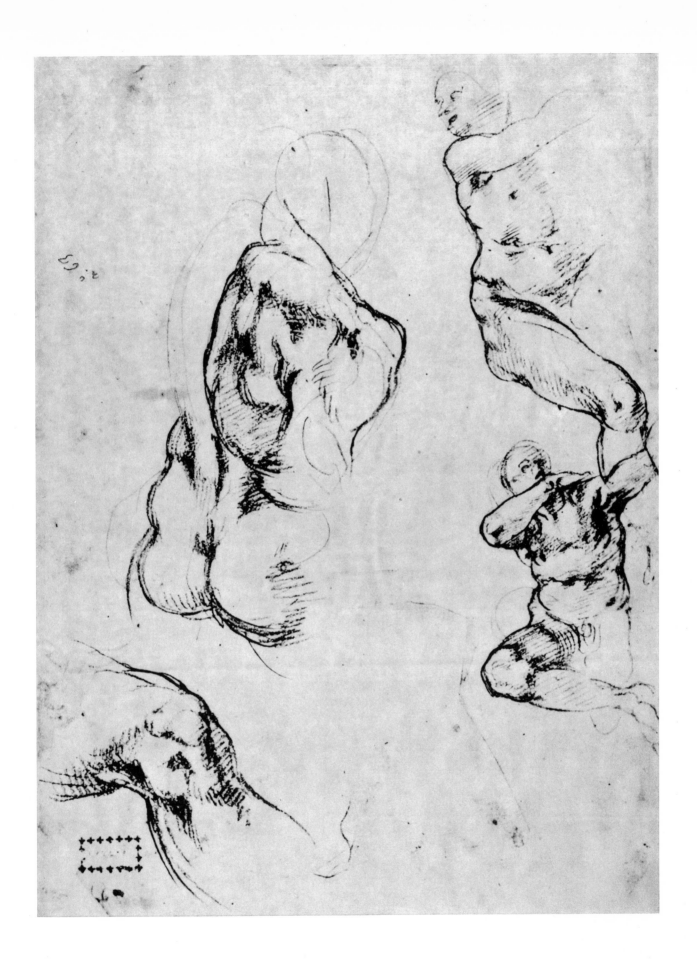

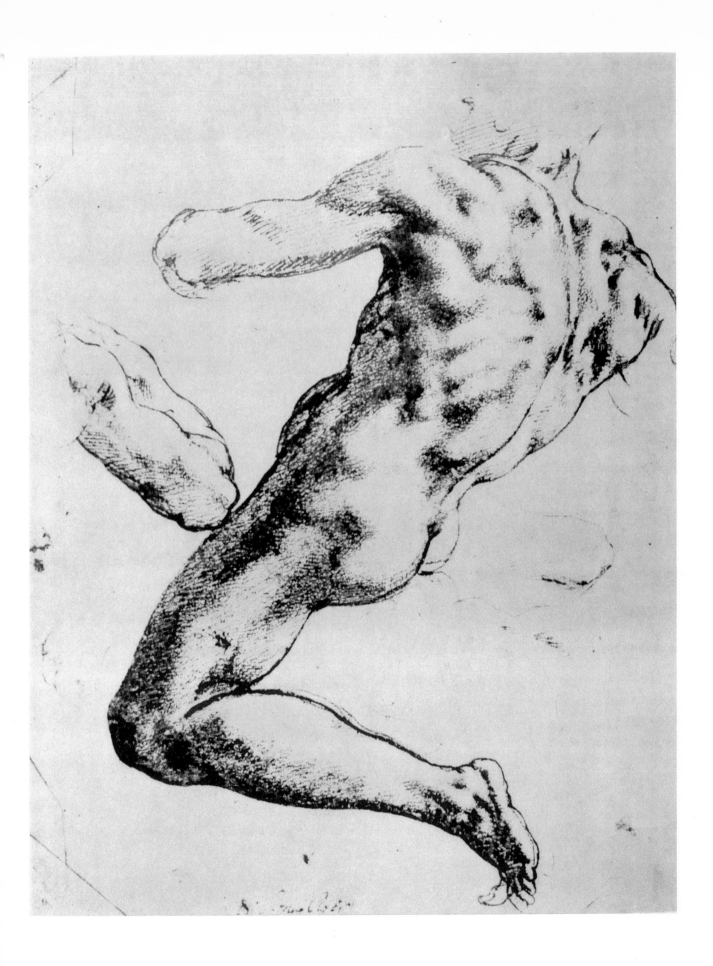

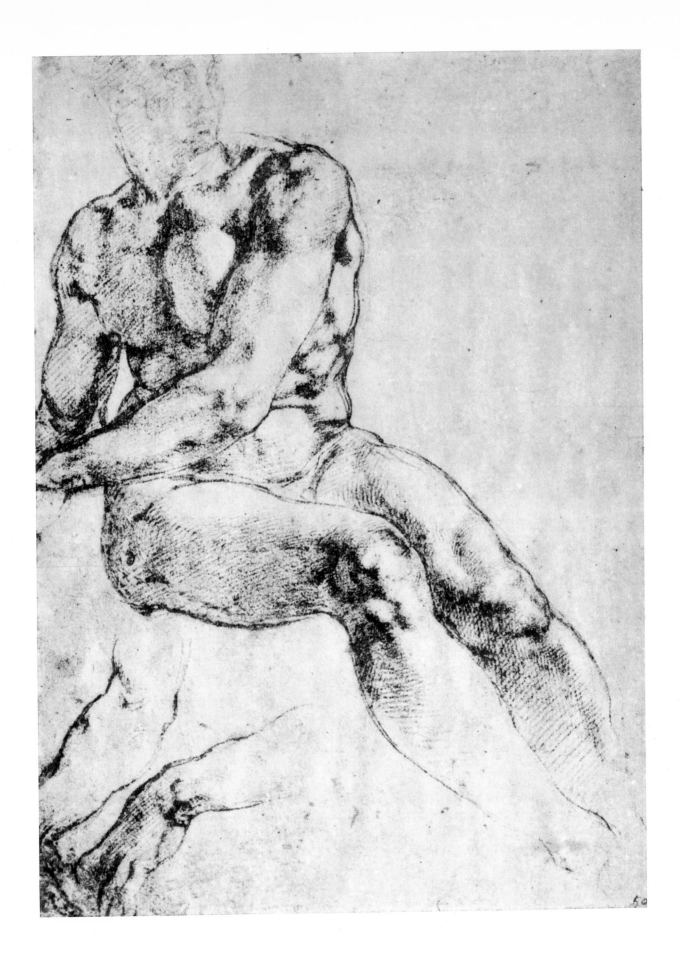

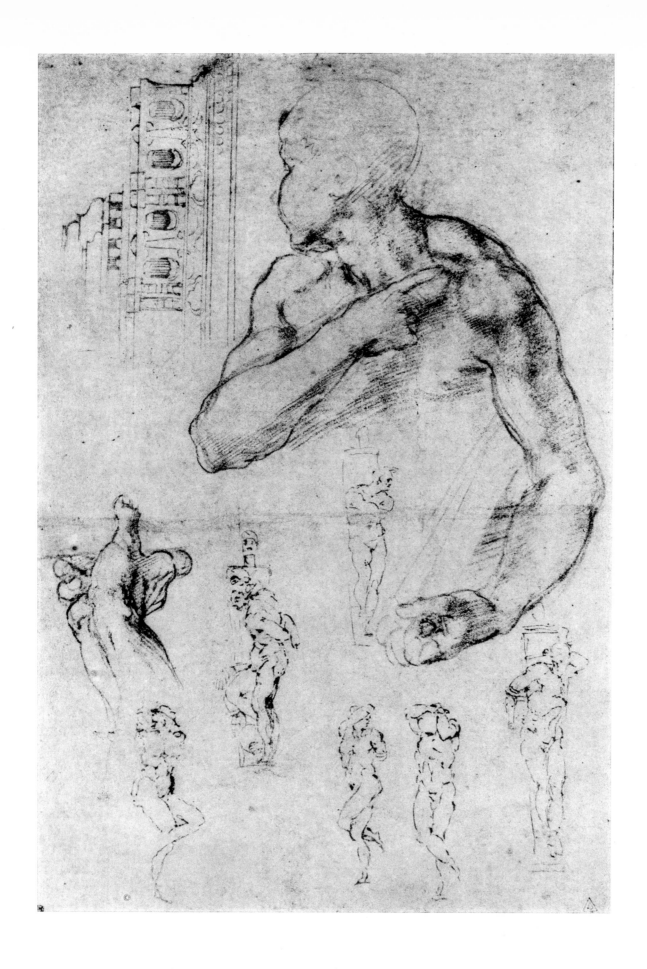

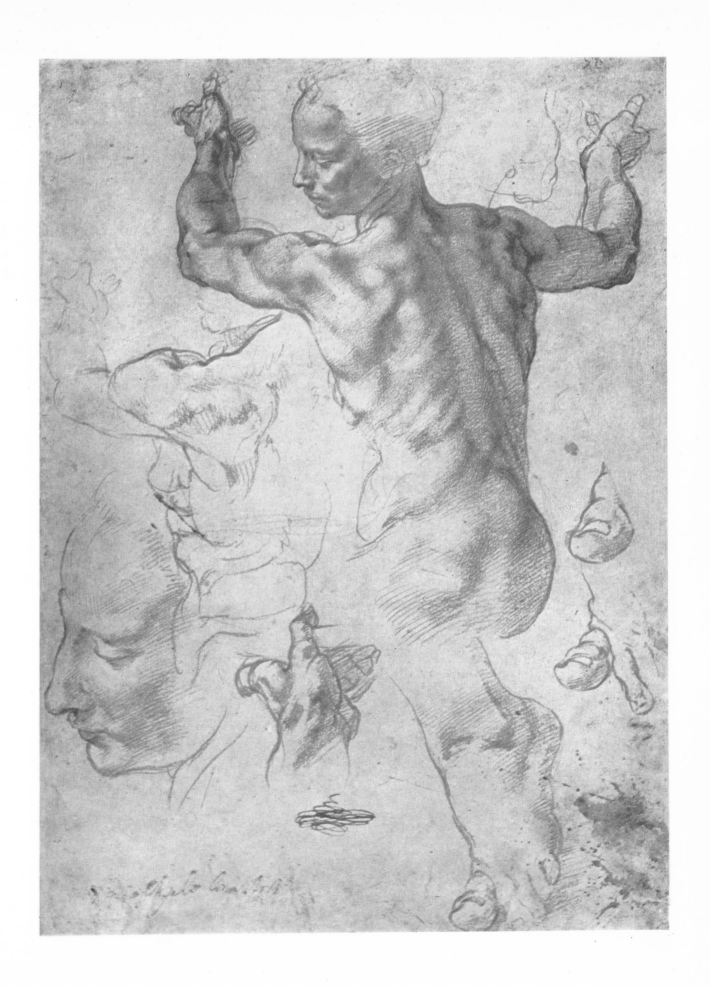

IV

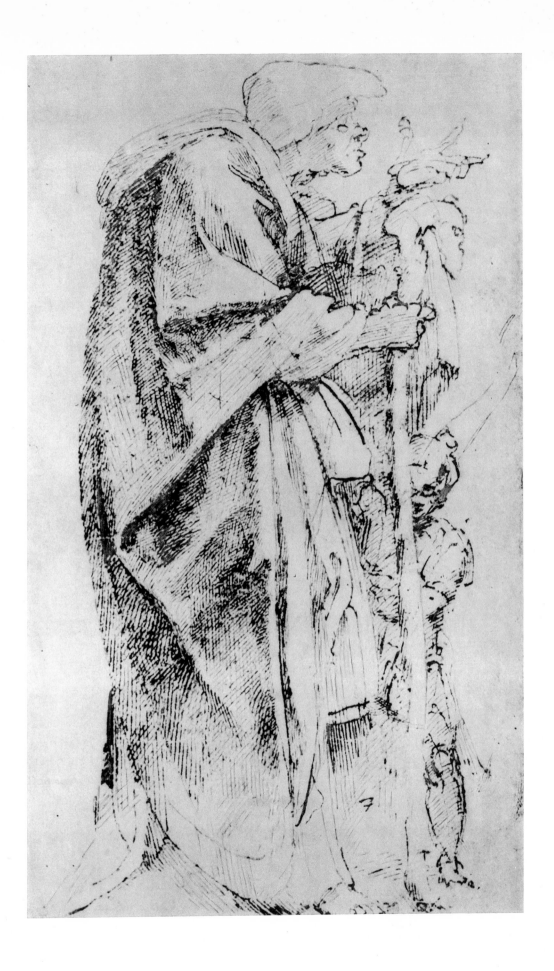

22

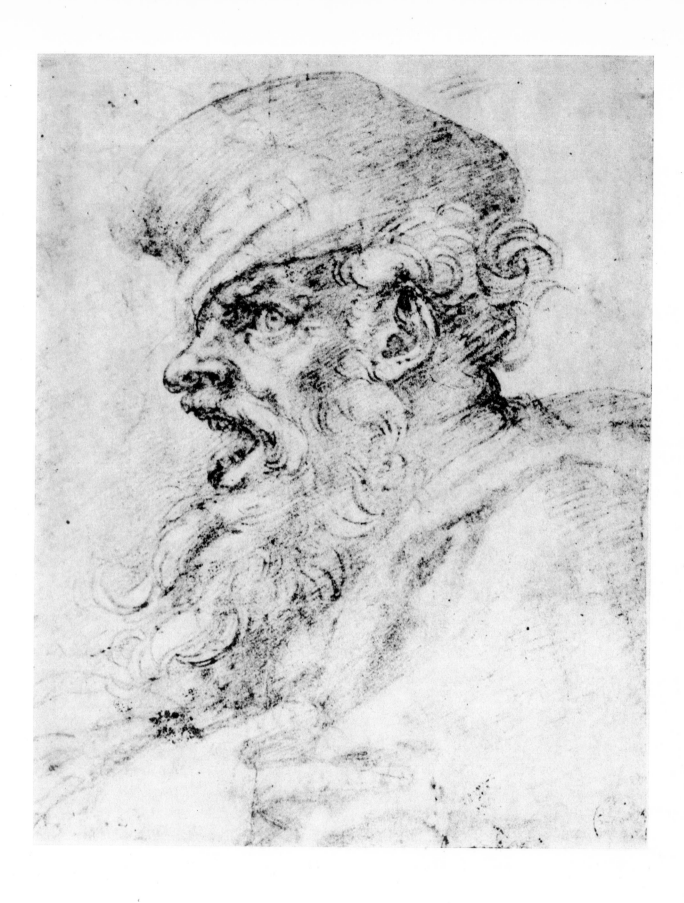

23

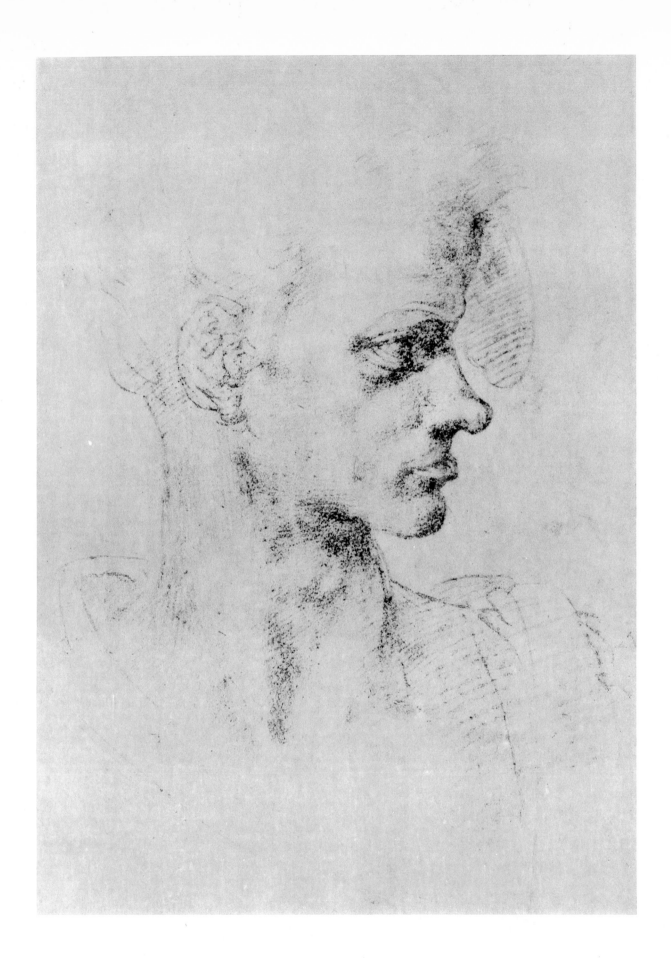

24

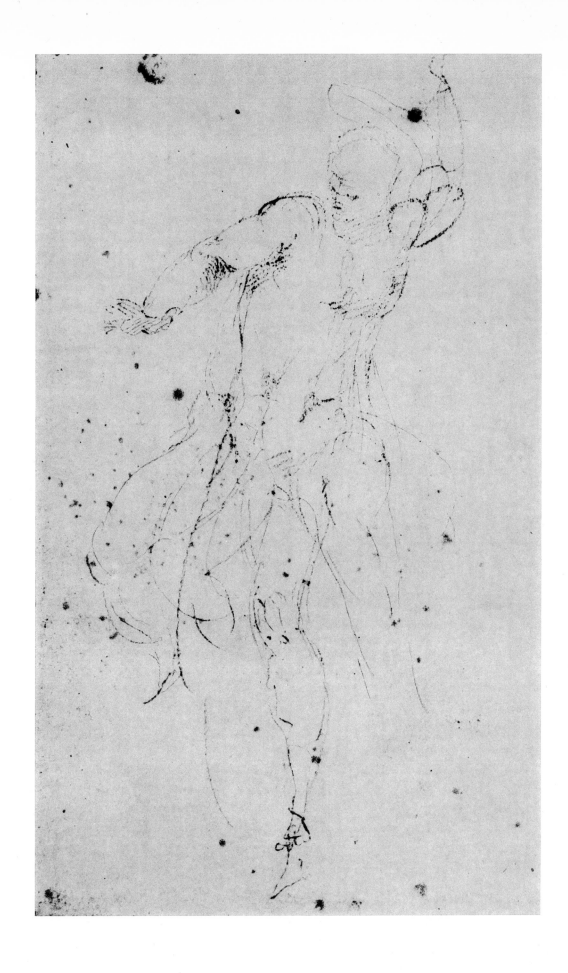

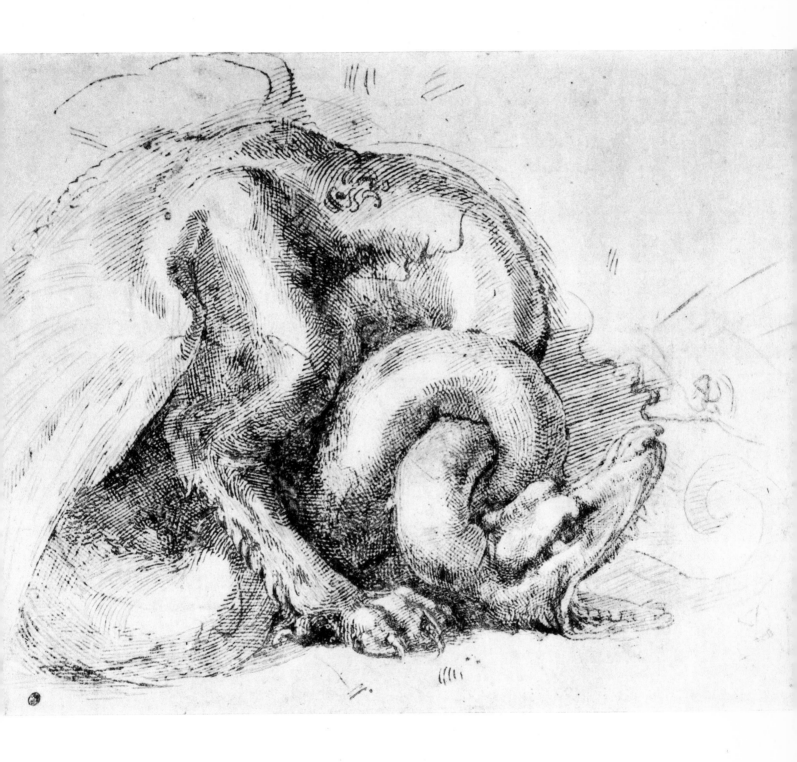

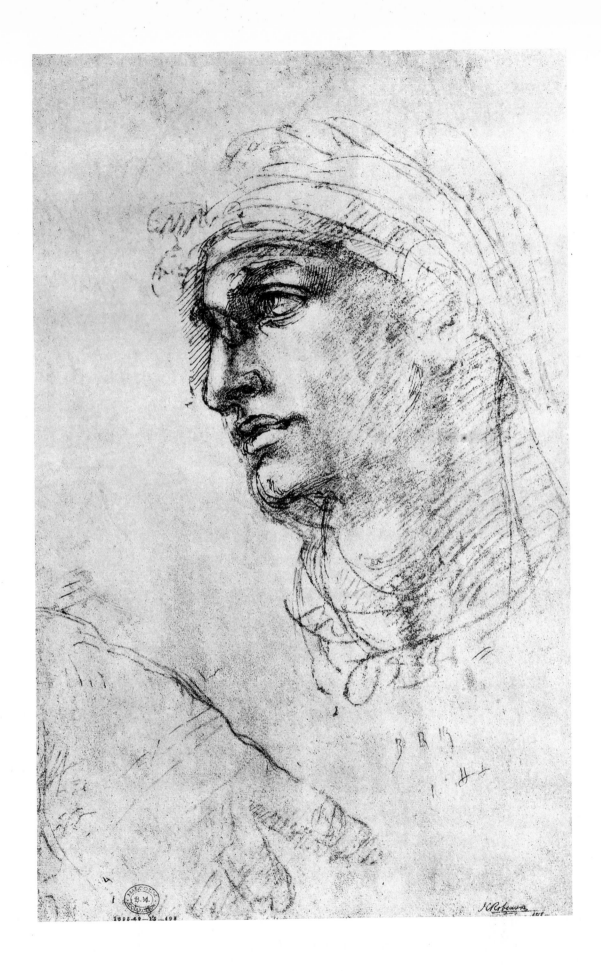

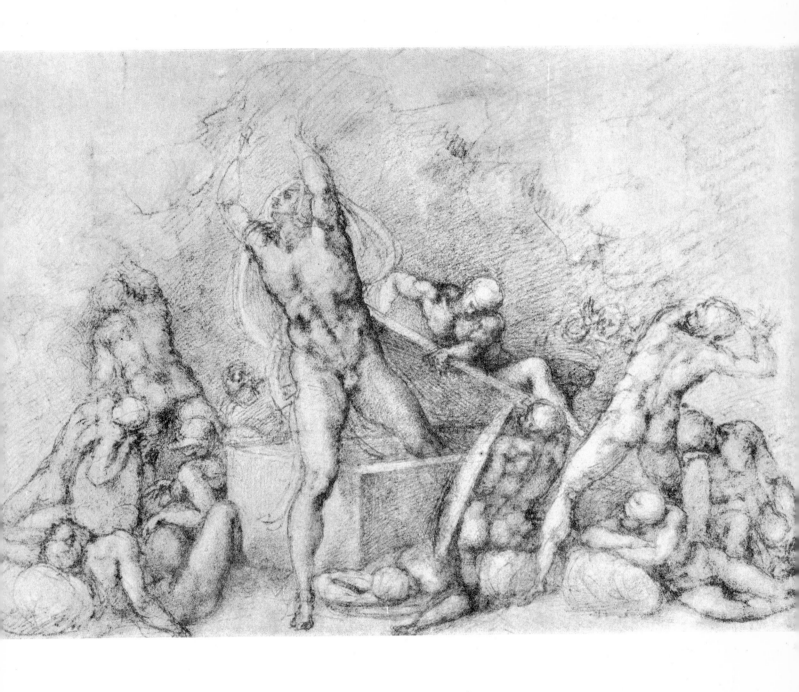

29

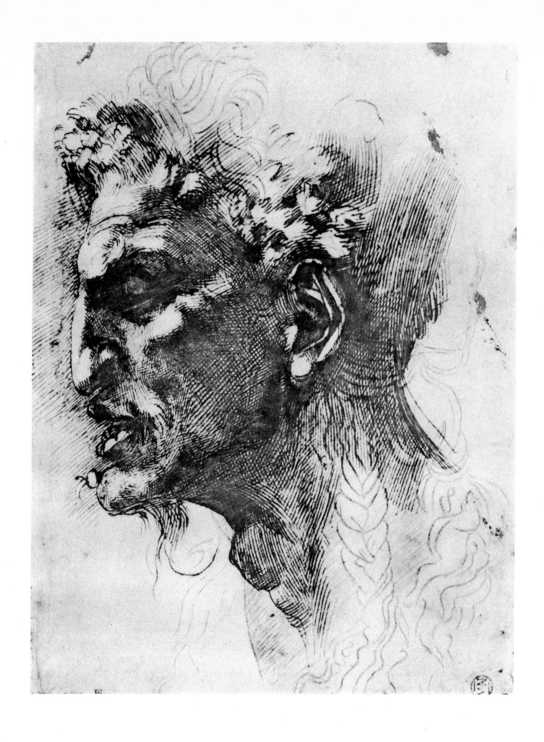

30

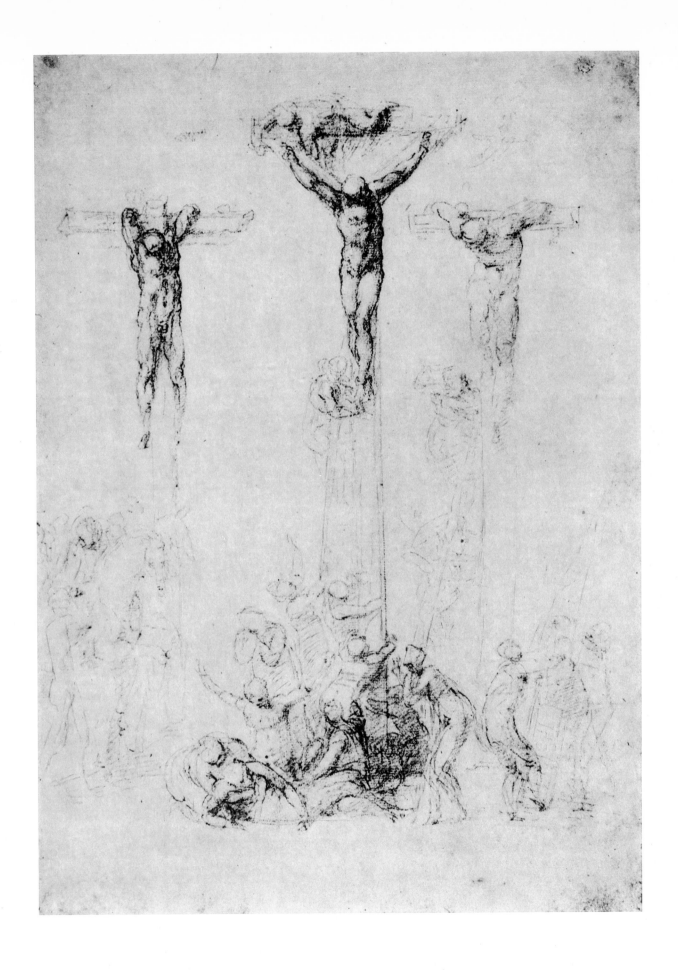

31

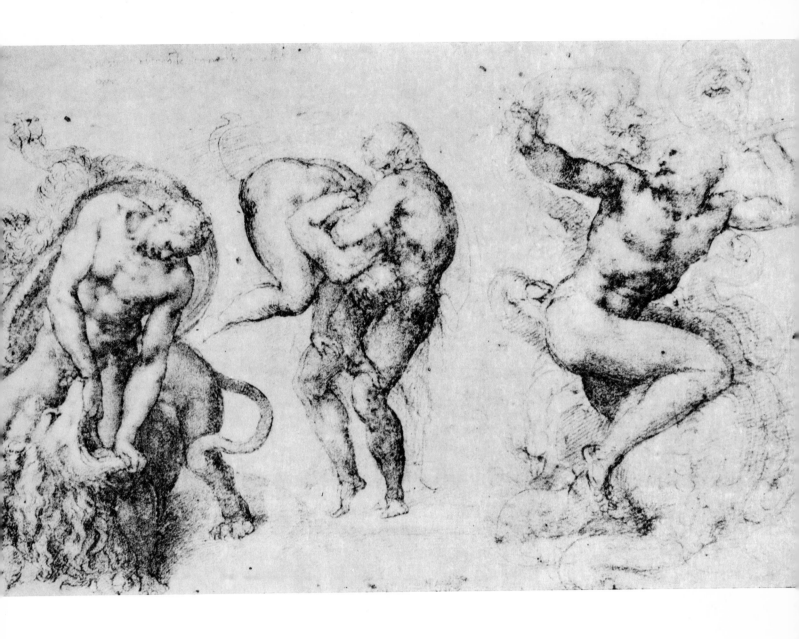

32

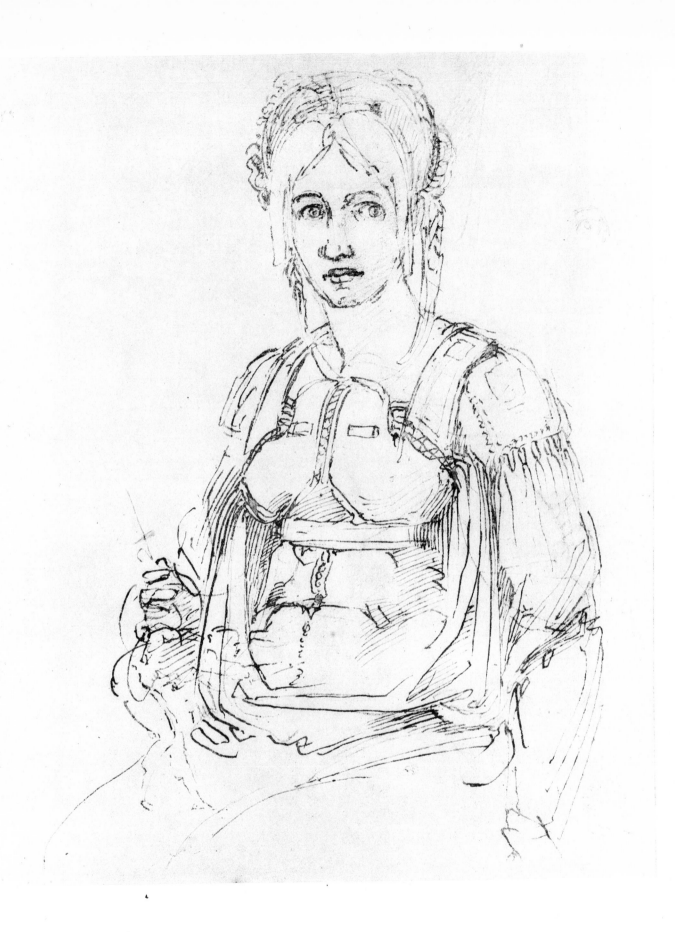

33

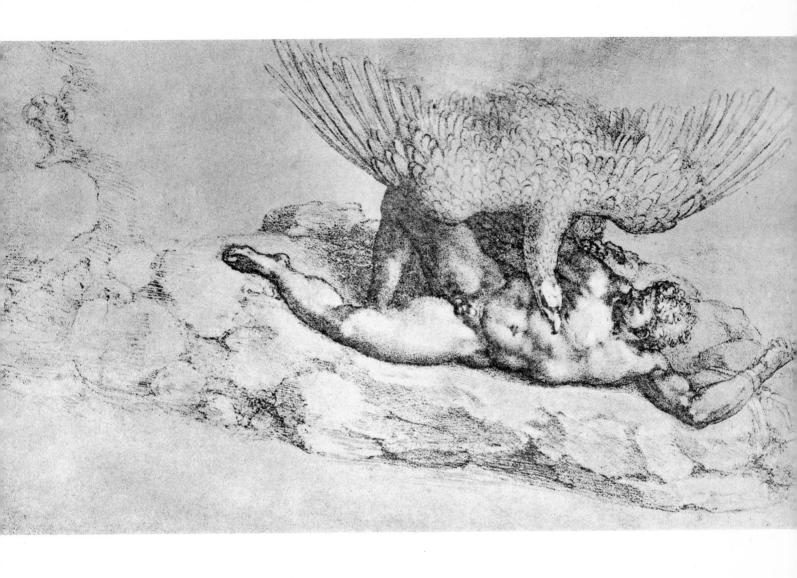

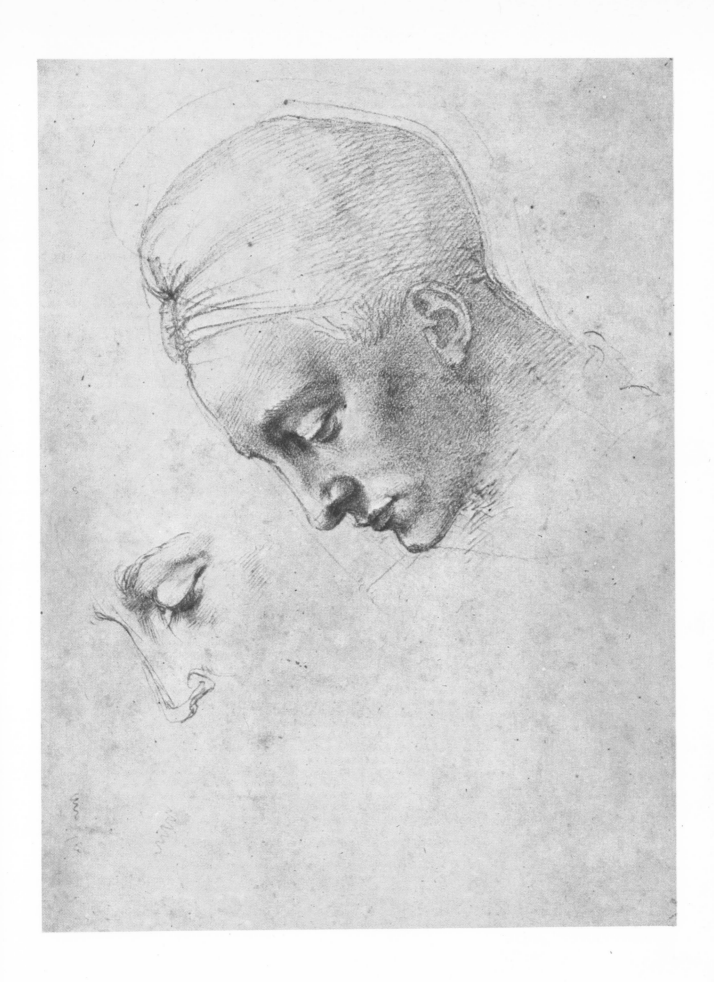

V

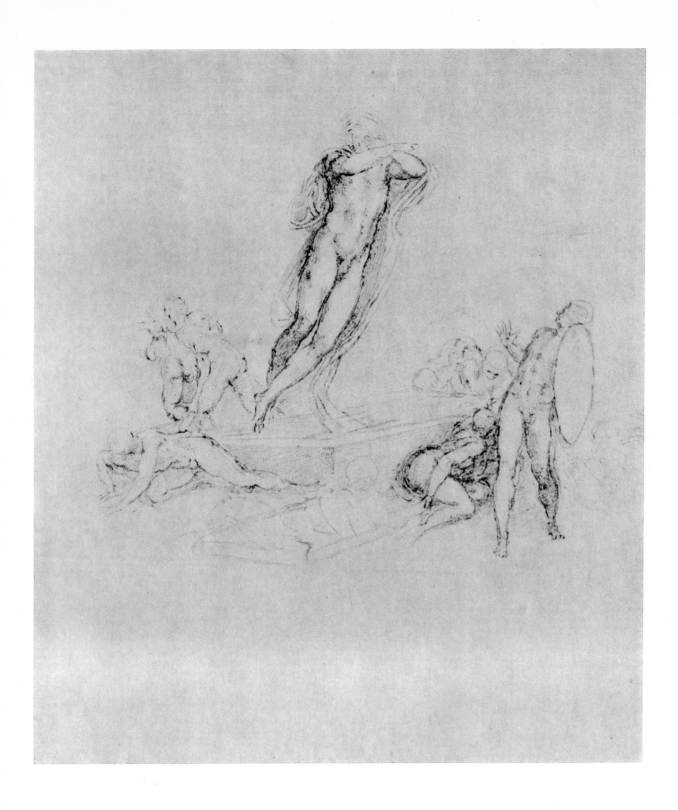

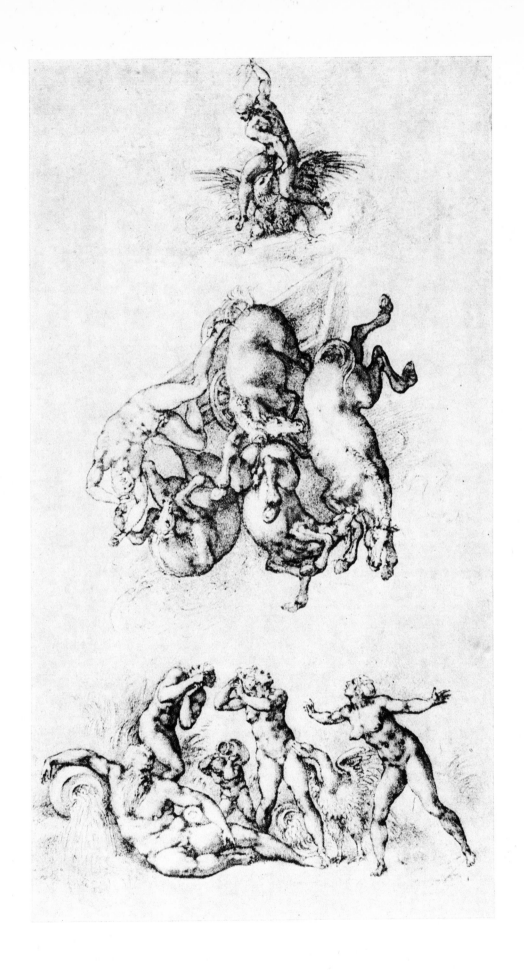

36

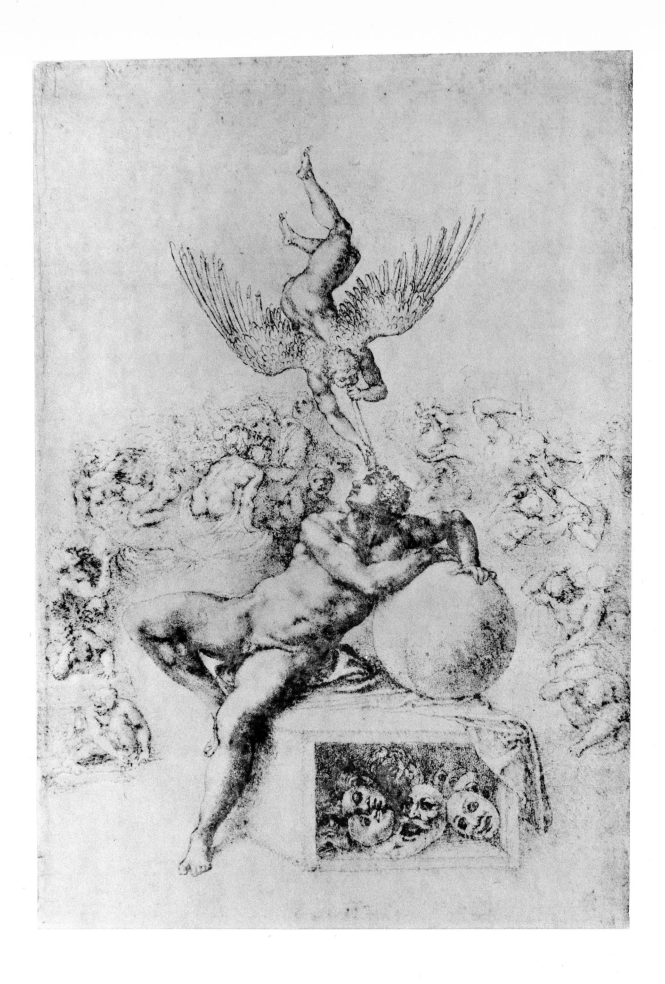

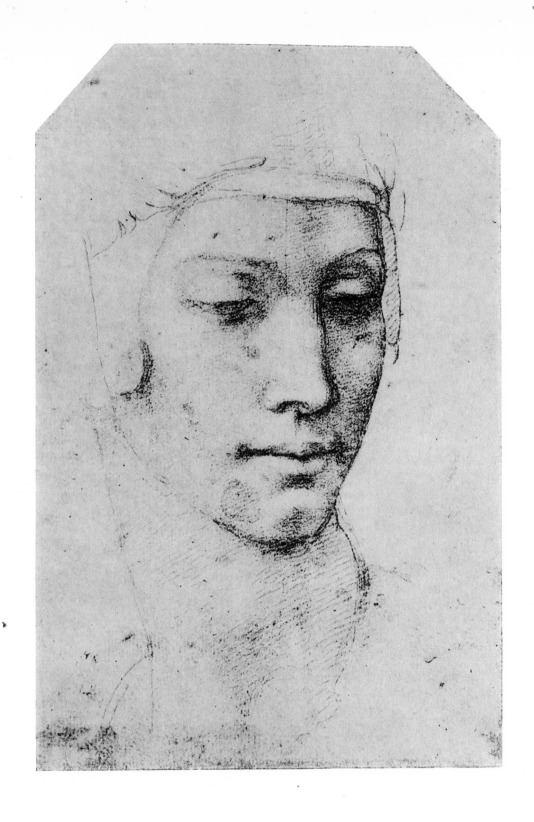

38

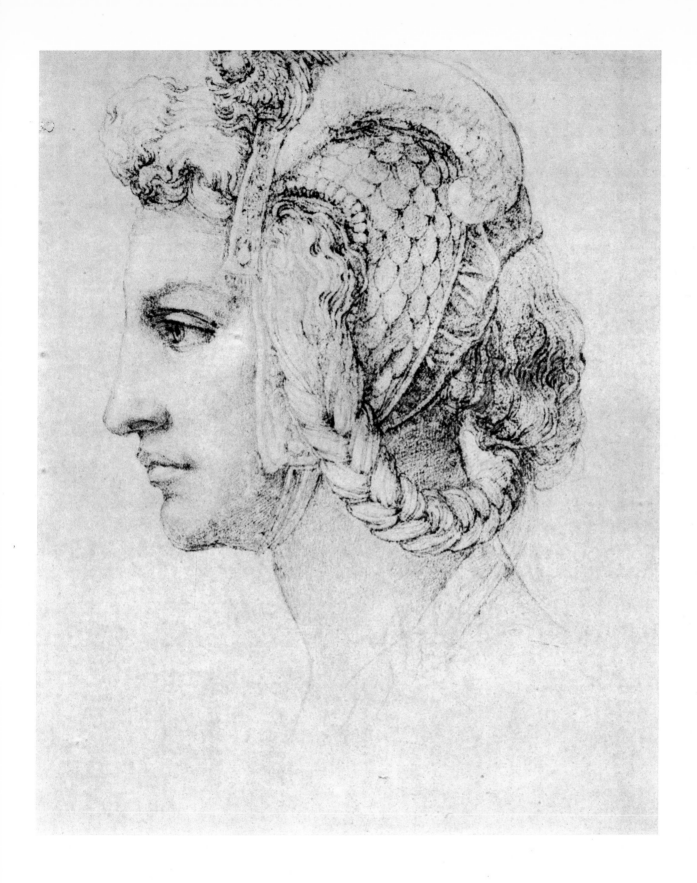

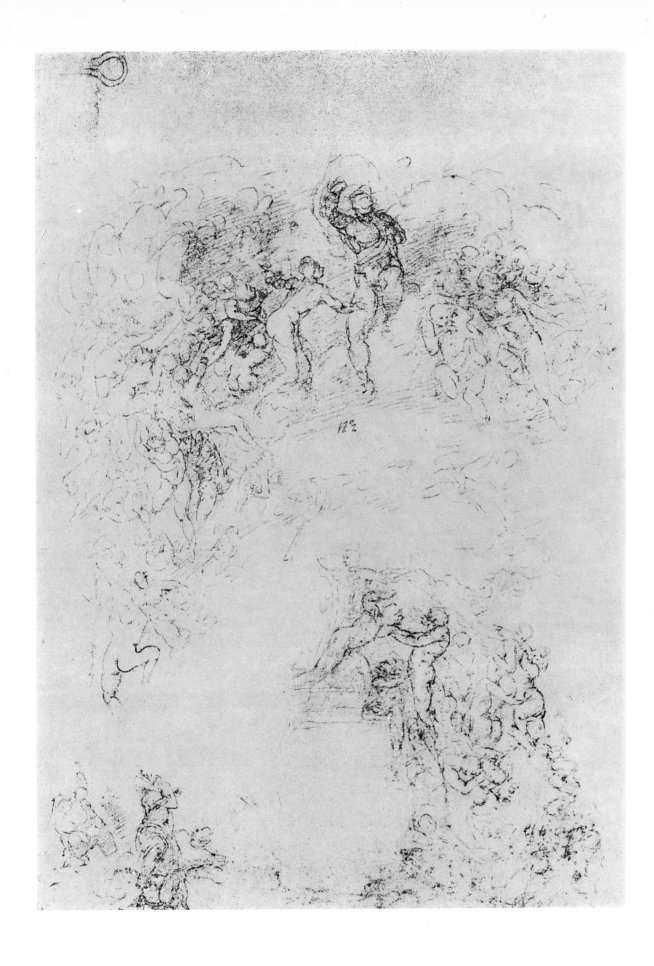

40

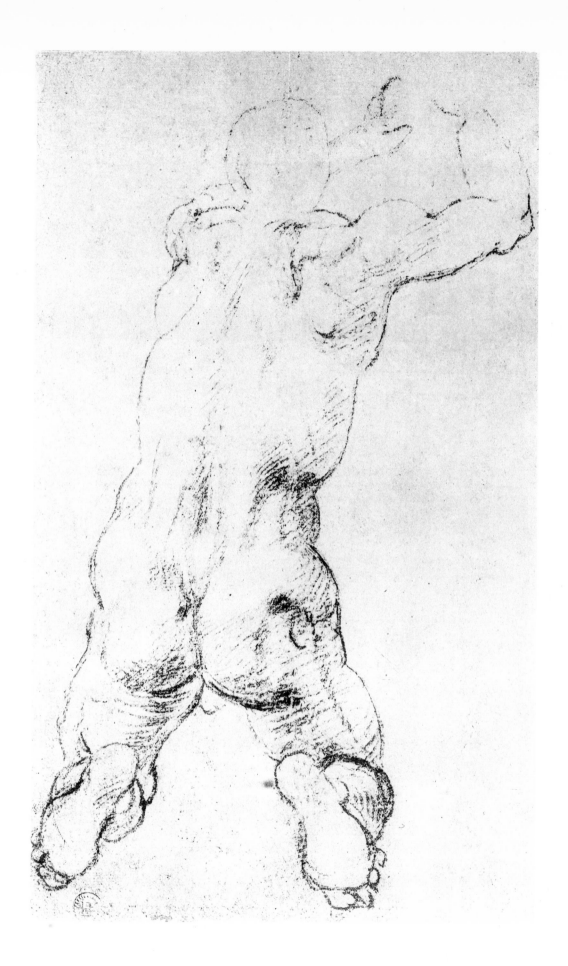

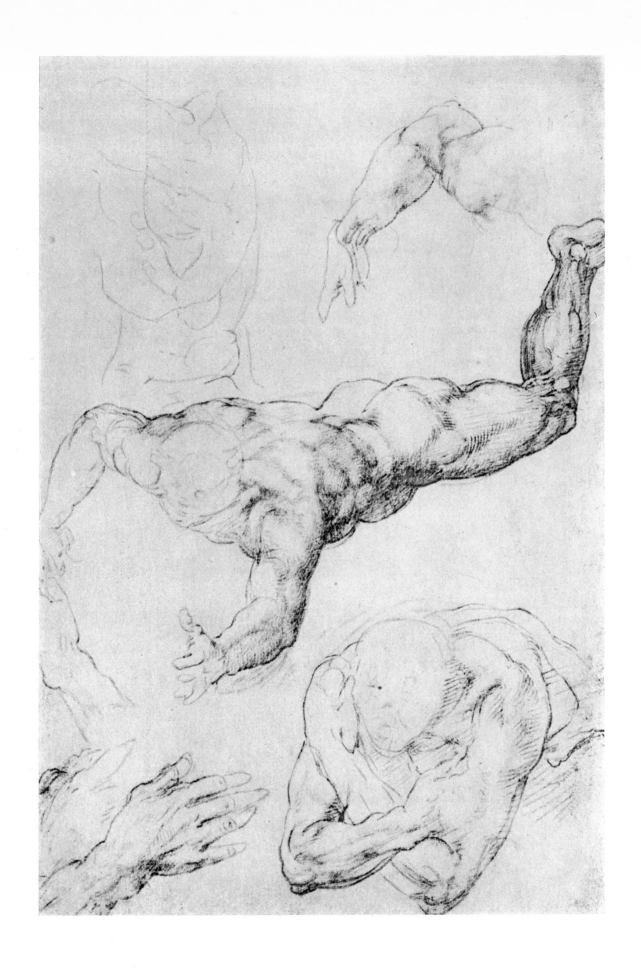

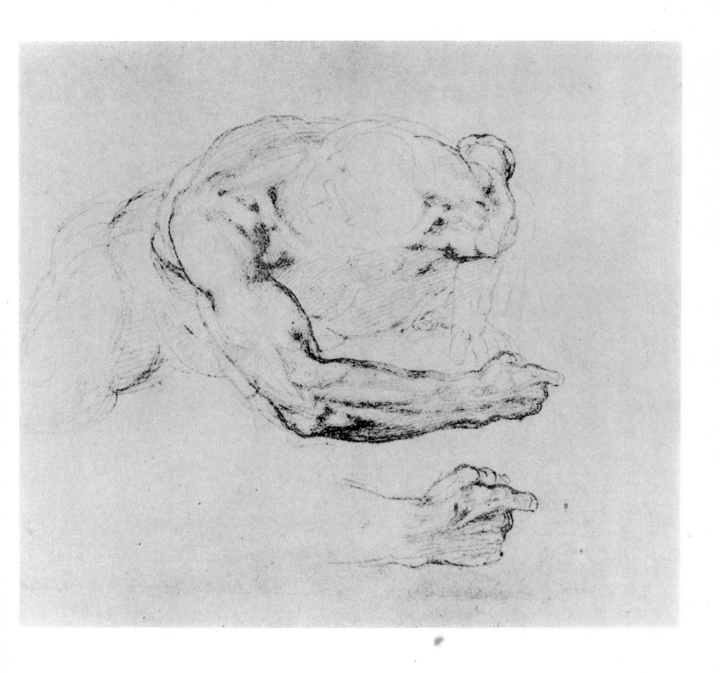

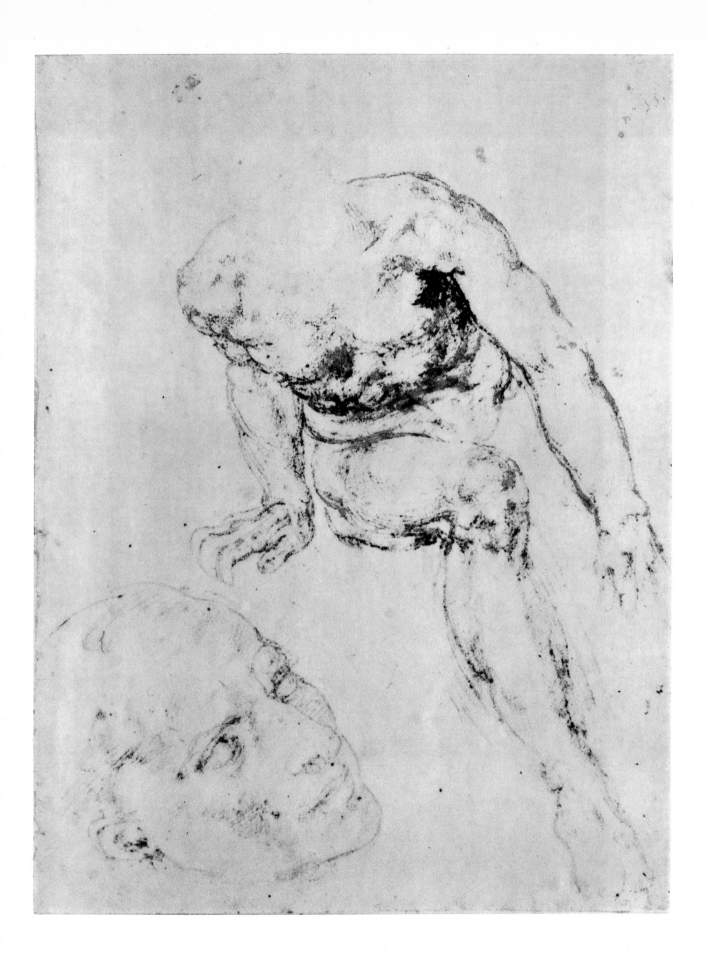

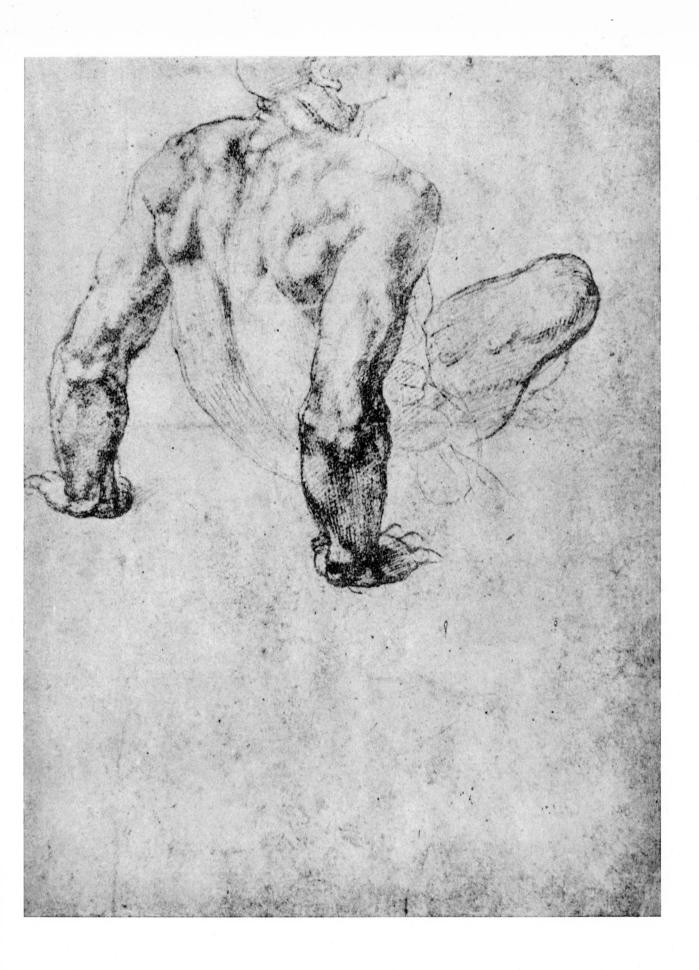

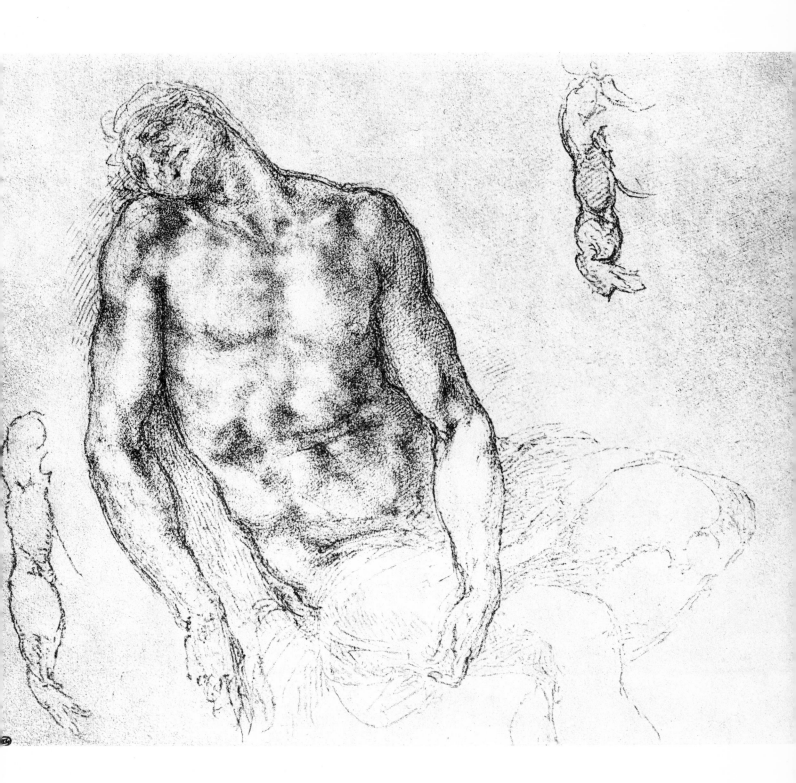

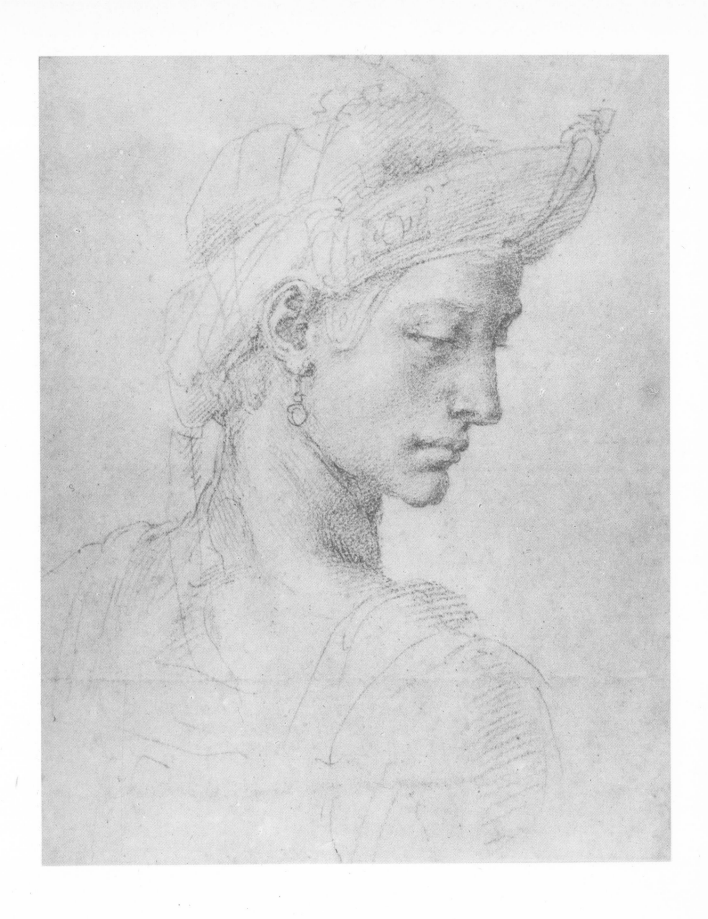

VI

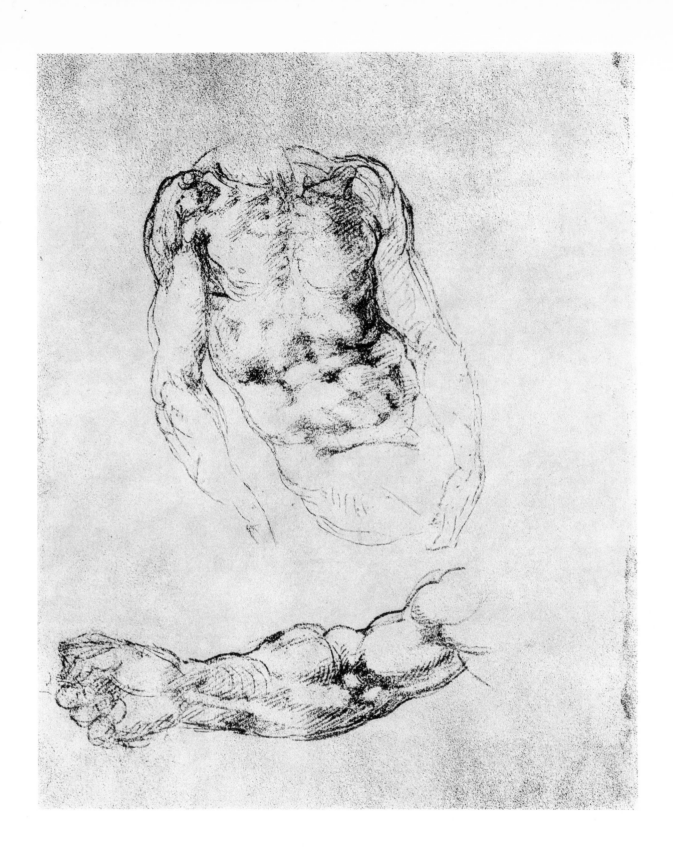

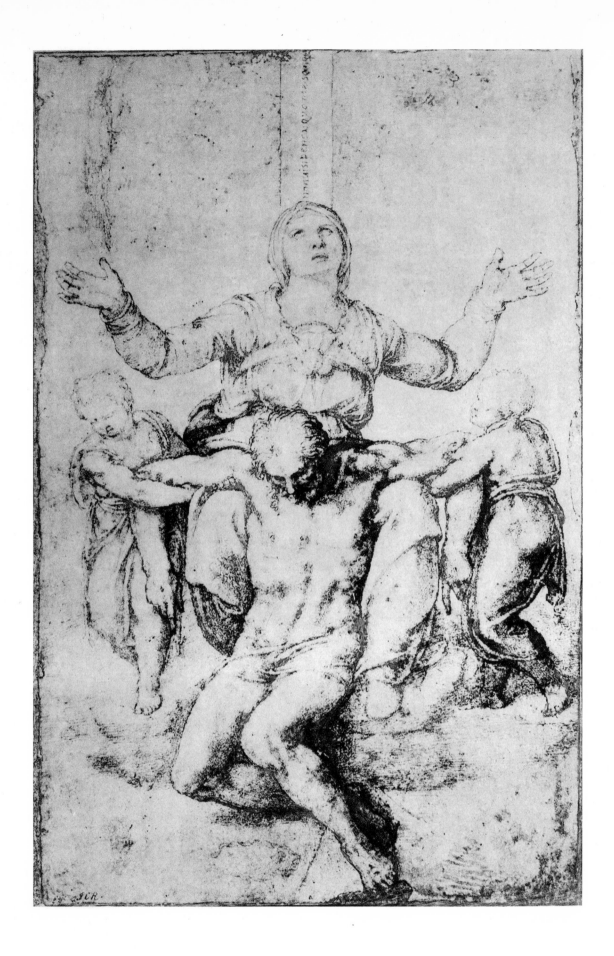

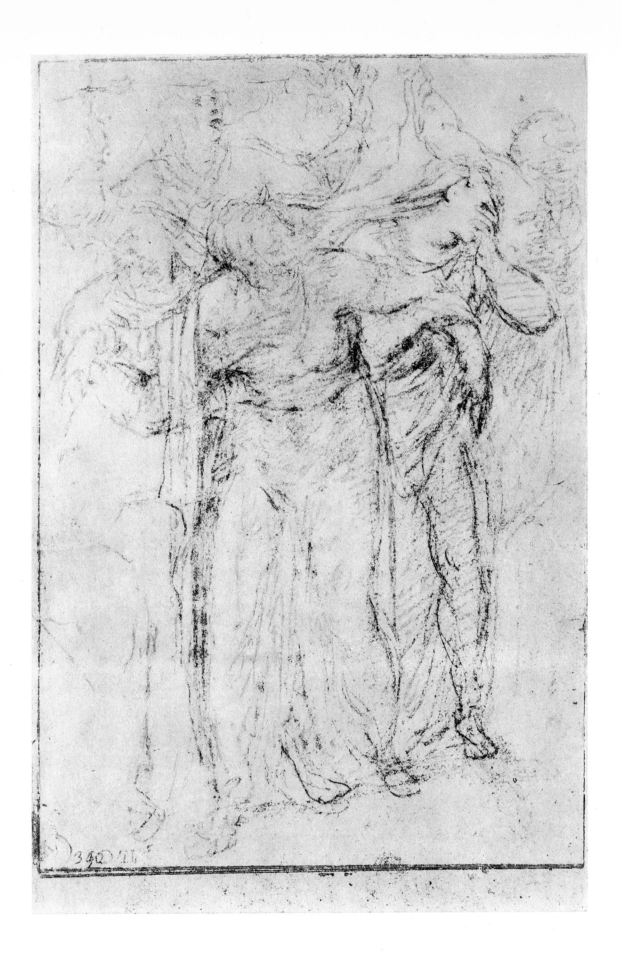

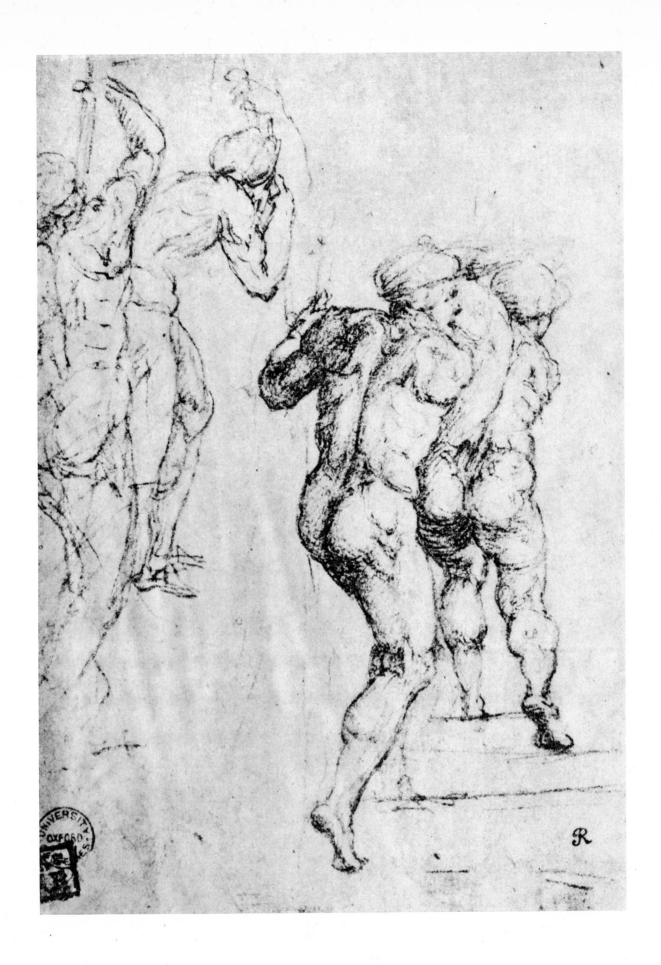

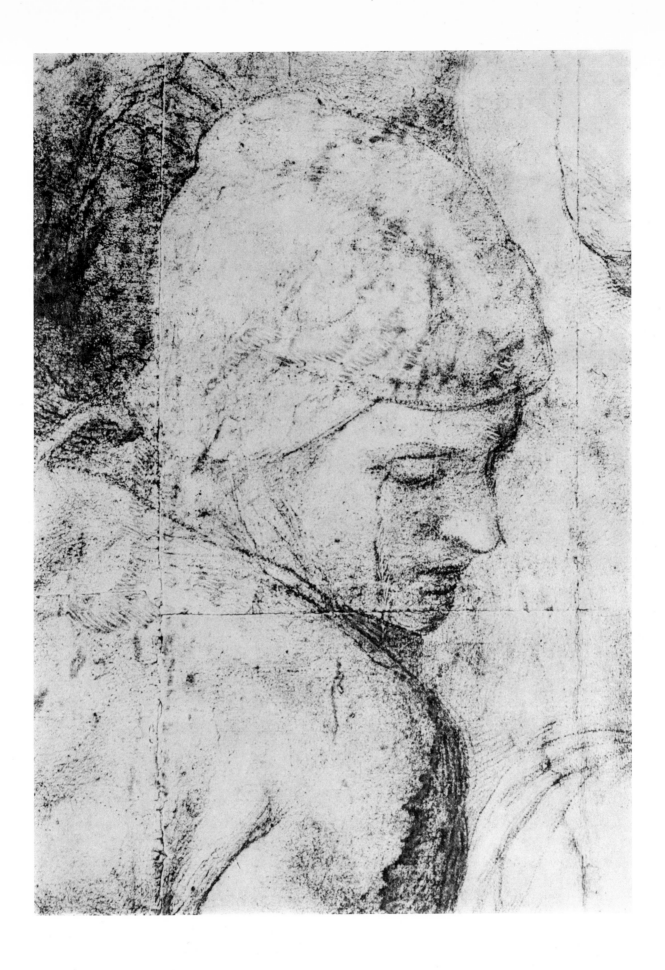

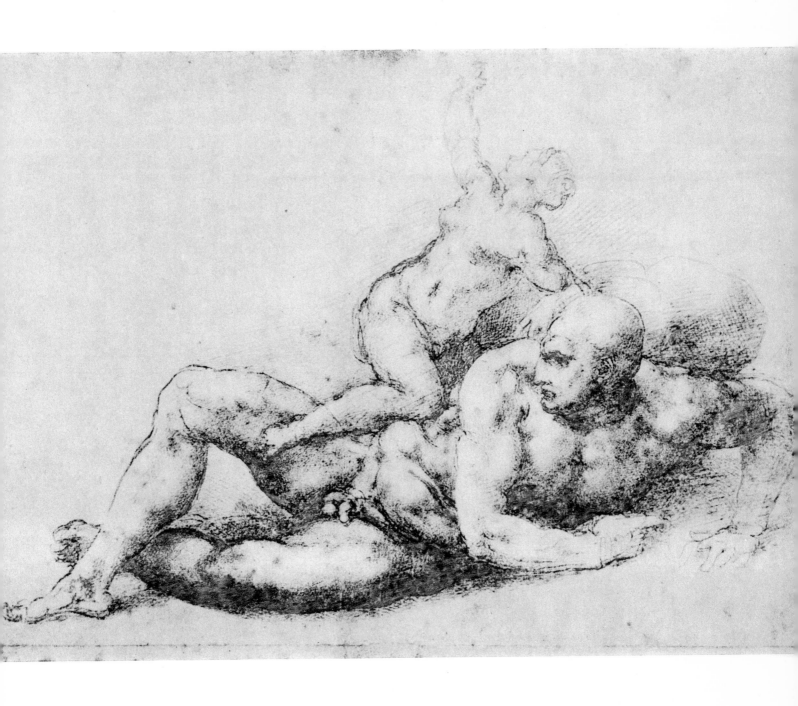

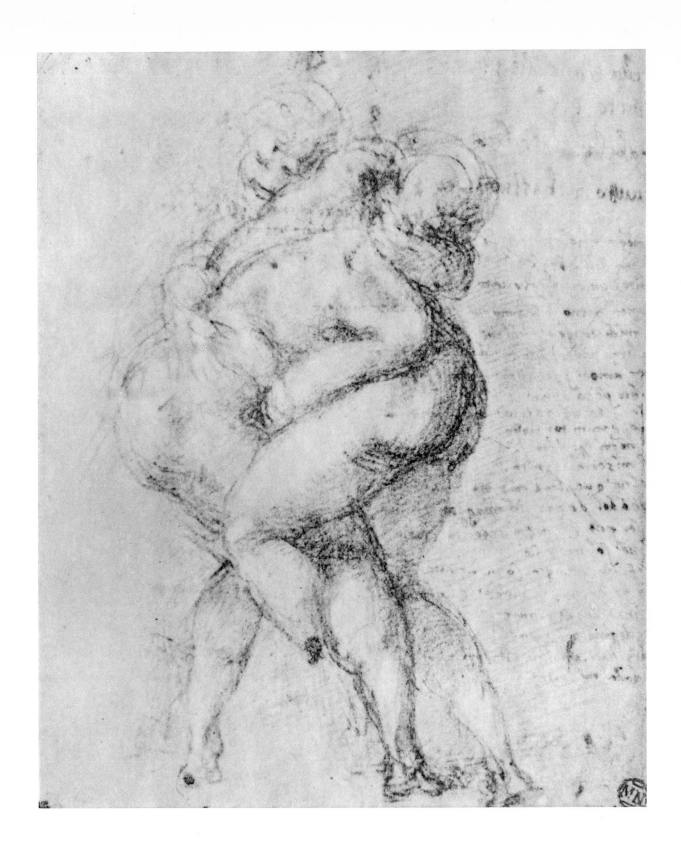

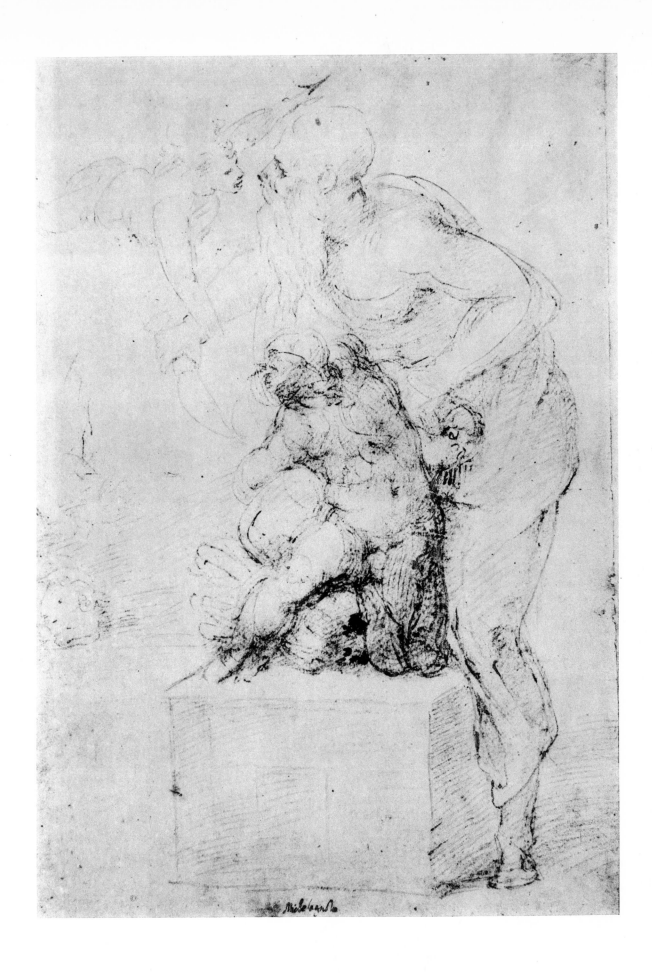

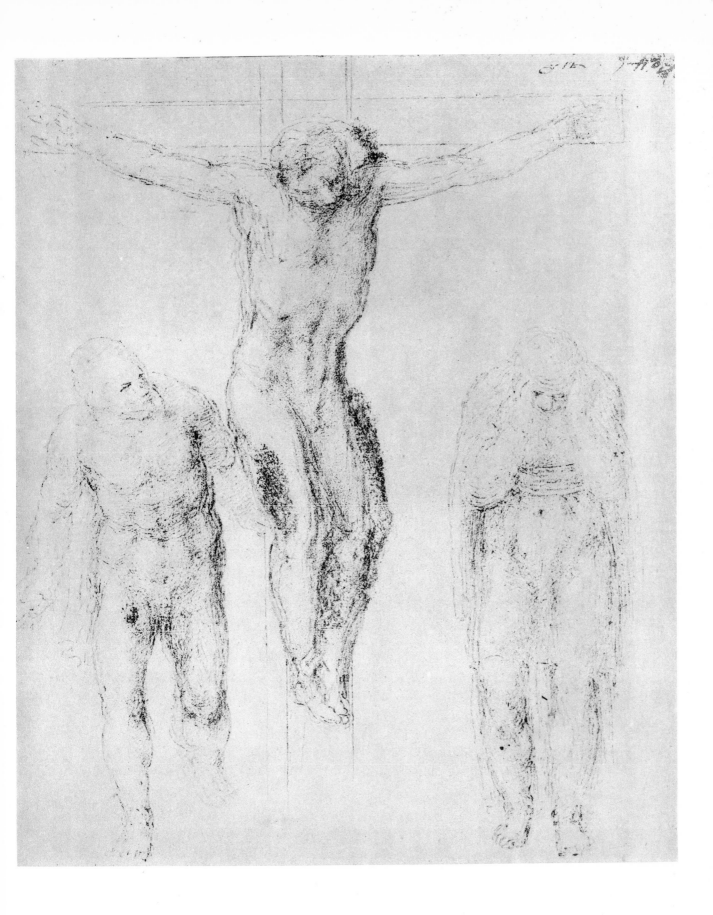

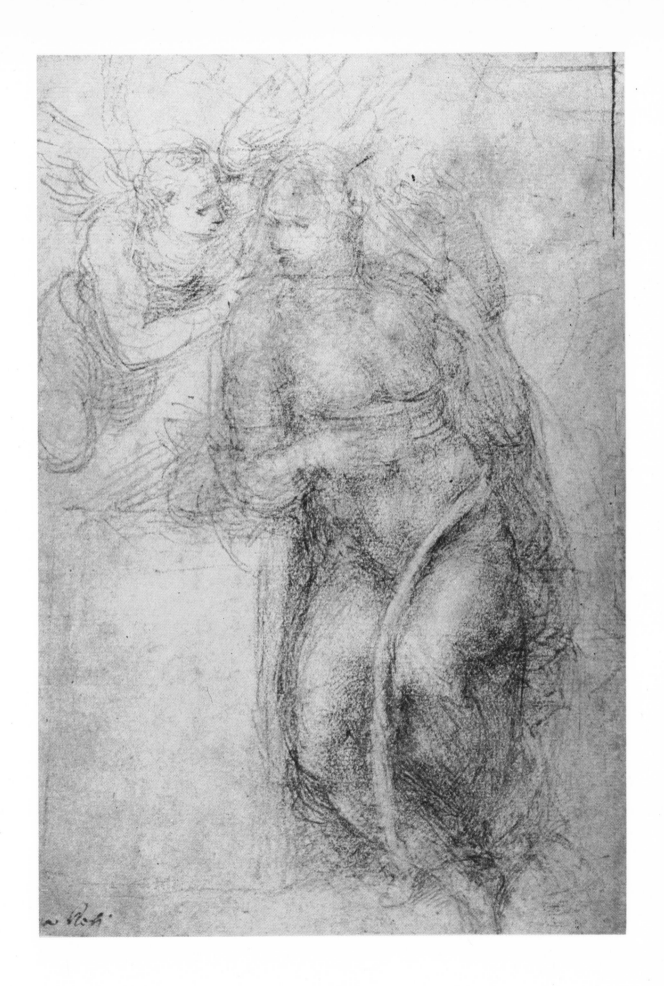

VII

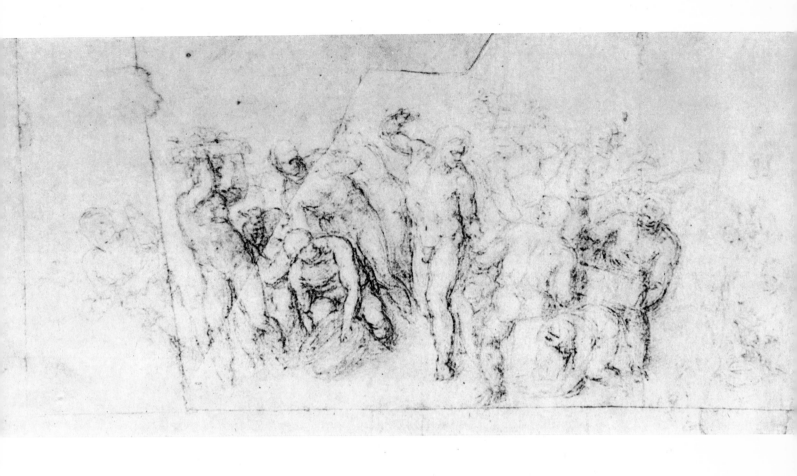

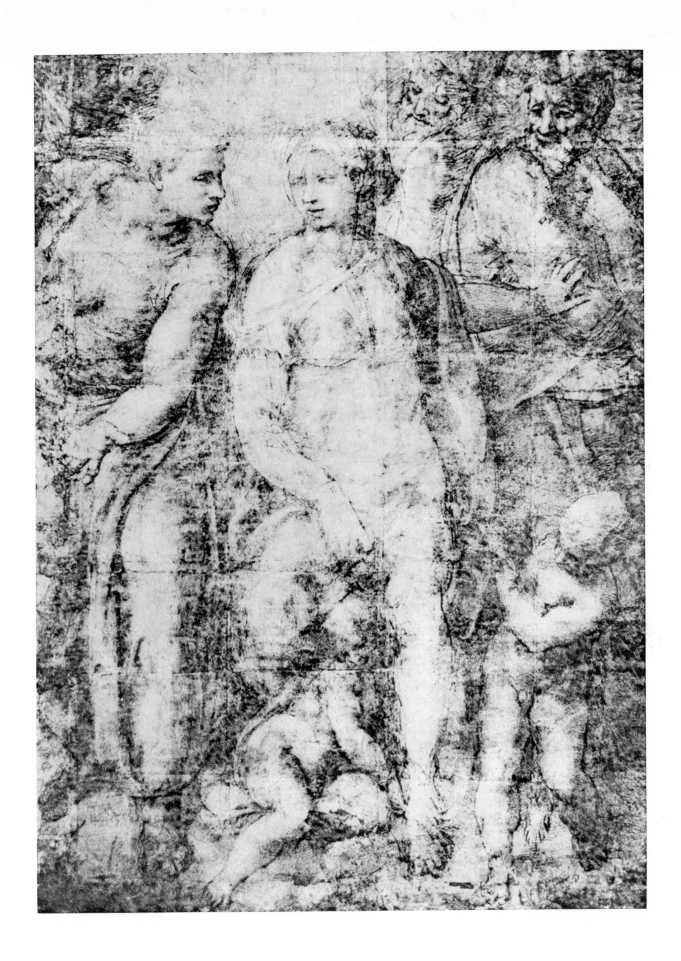

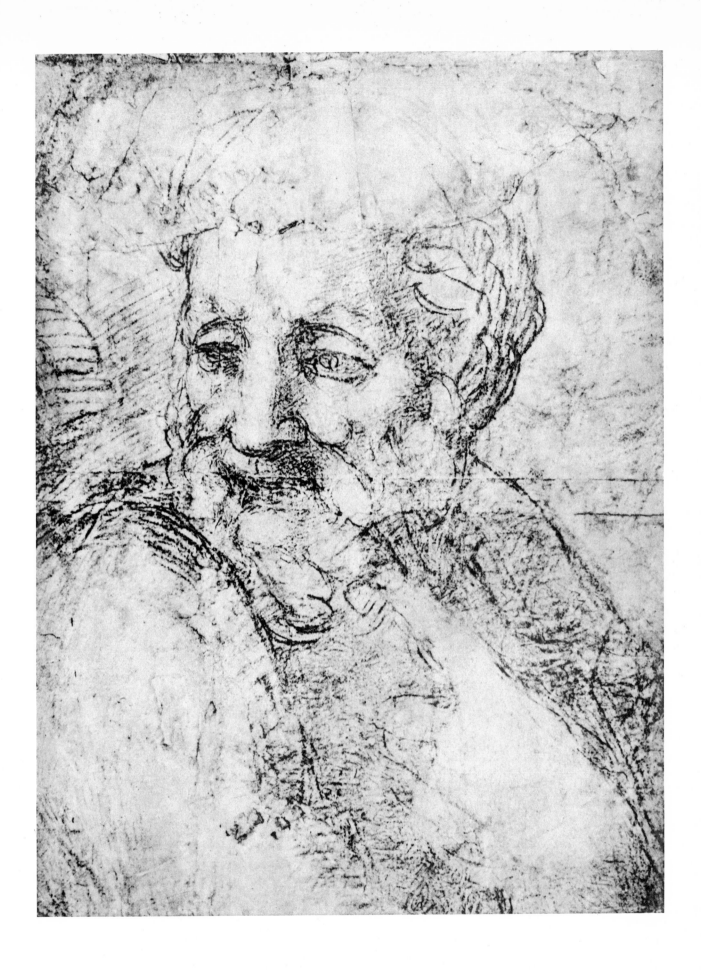

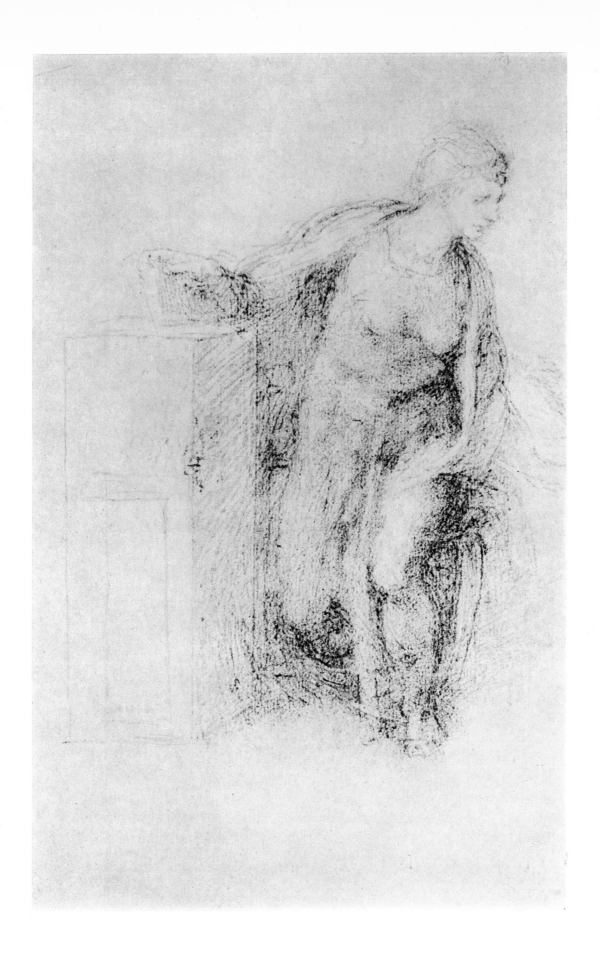

59

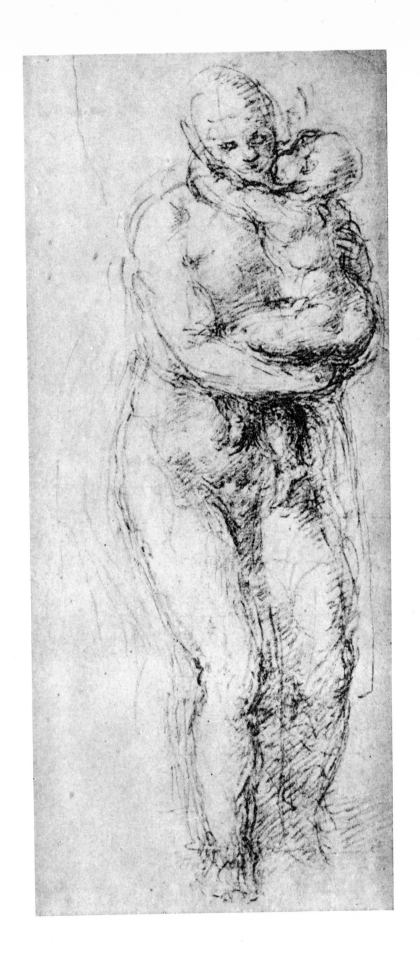

60

SELECTED BIBLIOGRAPHY

Barocchi, Paola. *Michelangelo e la Sua Scuola*. Volumes 1 and 2: Firenze: I Disegni della Casa Buanarroti e Degli Uffizi, 1962. Volume 3: Firenze: I Disegni dell'Archivio Buonarroti, 1964.

Battisti, Eugenio. "Michelangelo o dell'Ambiguita Iconografica." In *Fetschrift Luitpold Dussler*. Munich-Berlin, 1972, pp. 209–222.

Berenson, Bernard. *The Drawings of the Florentine Painters*. Second edition: Chicago, 1938. Third edition: Milan, 1963.

Brinckmann, A.E. *Michelangelo-Zeichnungen*. Munich, 1925.

Coughlan, Robert and the Editors of Time-Life Books. *The World of Michelangelo, 1475–1564*. New York: Time-Life Books, 1966.

Dussler, Luitpold. *Die Zeichnungen des Michelangelo*. Munich, 1925.

Frey, Karl. *Die Handzeichnungen Michelagniolos Buonarroti*. In three volumes. Berlin, 1909–1911.

Knapp, Fritz. *Die Handzeichnungen Michelagniolos Buonarroti*. Berlin: Nachtrag, 1925.

Goldscheider, Ludwig. *Michelangelo: Selected Drawings*. London, 1951.

Hartt, Frederick. *The Drawings of Michelangelo*. London, 1971.

Hirst, Michael. "The Drawing of the Rape of Ganymed by Michelangelo." In *The Burlington Magazine*, volume 66 (1975), p. 166.

Hlaváček, Luboš. "Nad Kresbami Michelangela. Ke 400. Výročí Umělcovy Smrti" (The Drawings of Michelangelo. On the occasion of the 400th Anniversary of the Artist's Death). In *Umeni*, volume 12 (Prague, 1964), pp. 541–574.

Panofsky, Erwin. "The Neoplatonic Movement and Michelangelo." In *Studies of Iconology*, New York, 1939.

Parker, K.T. *Catalogue of the Collection of Drawings in the Ashmolean Museum. Volume 2: Italian Schools*. Oxford, 1956.

Pečírka, Jaromír. *Leonardo—Michelangelo. Kresby*. (Leonardo—Michelangelo. Drawings.) Prague, 1957.

Perrig, Alexander. "Bemerkungen zur Freundschaft zwischen Michelangelo und Tommaso de'Cavalieri." In *Stil und Überlieferung in der Kunst des Abendlandes. Akten des 21. Internationalen Kongresses für Kunstgeschichte in Bonn, 1964. Volume II: Michelangelo*. Berlin, 1967, pp. 164–171.

Poirier, Maurice. "The Role of the Concept of *Designo* in Mid-Sixteenth Century Florence." In *The Age of Vasari. A Loan Exhibition*. Indiana: University of Notre Dame Art Gallery; New York: University Art Gallery, State University of New York at Binghamton, 1970, pp. 53–68.

Popham, A.E. and Wilde, Johannes. *Italian Drawings at Windsor Castle*. London, 1949.

————. *Summary of an Exhibition of Drawings by Michelangelo*. London: British Museum, 1953.

Regteren Altena, Johan Quirijn van. "Zu Michelangelos Zeichnungen, besonders aus den Jahren 1530 bis 1535." In *Stil und Überlieferung*, Berlin, pp. 171–180.

Thode, Henry. *Michelangelo: Kristische Untersuchungen über sein Werk. Volume III*. Berlin, 1913.

Tolnay, Charles de. *Michelangelo*. In six volumes. New Jersey: Princeton University, 1943.

Vasari, Giorgio. *Lives of the Painters, Sculptors and Architects*. In four volumes. New York: E.P. Dutton (Everyman's Library), 1963.

Weinberger, Martin. "Bemerkungen zu einer Michelangelo-Zeichnung." In *Festschrift Ulrich Middeldorf*. Berlin, 1968, pp. 233–240.

Wilde, Johannes. *Italian Drawings in the Department of Prints and Drawings in the British Museum. Michelangelo and His Studio*. London, 1953.

————. *Michelangelo's "Victory."* Oxford, 1954.